Amphoto Guide to
Photographing Models

Amphoto Guide to
Photographing Models

Ted Schwarz

AMPHOTO
American Photographic Book Publishing Co., Inc.
New York, New York 10036

Note: In the appendix of this book, you will find a table for converting U.S. Customary measurements to the metric system. You will also find a table for ASA and DIN equivalents.

All photographs were taken by the author unless otherwise noted.

Published in New York, New York by American Photographic Book Publishing Co., Inc.

Library of Congress Cataloging in Publication Data
Schwarz, Ted.
 Amphoto guide to photographing models.

 Includes index.
 1. Photography, Commercial. 2. Fashion
photography. 3. Photography of the nude. I. Amphoto,
New York. I. Title.
TR690.S35 770'.28 79-10207
ISBN 0-8174-2474-1 (hardbound)
ISBN 0-8174-2146-7 (softbound)

Manufactured in the United States of America

10 9 8 7 6 5 4 3 2

OTHER BOOKS IN THE AMPHOTO GUIDE SERIES

Available now

Amphoto Guide to Basic Photography
Amphoto Guide to Cameras
Amphoto Guide to Black-and-White Processing and Printing
Amphoto Guide to Filters
Amphoto Guide to Selling Photographs
Amphoto Guide to Travel Photography

To be published

Amphoto Guide to Available Light Photography
Amphoto Guide to Darkroom Special Effects
Amphoto Guide to Non-Silver Processes

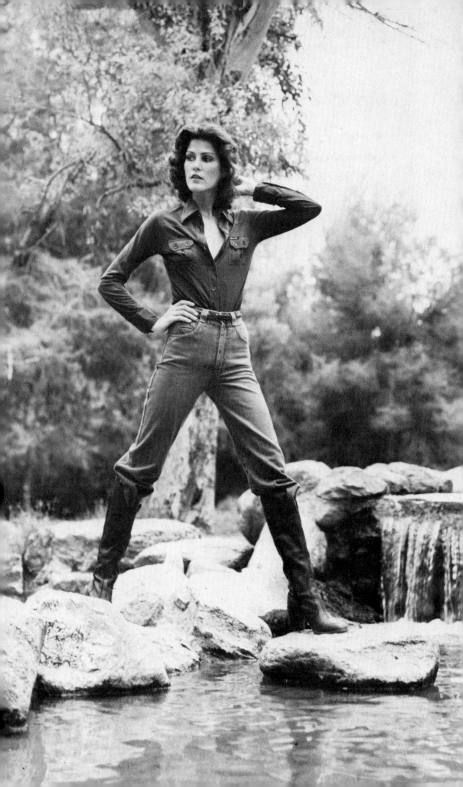

Contents

1

Model Photography:
An Overview

Mention model photography and what comes to mind: beautiful women and handsome men in exotic locations? high-fashion-evening gowns and designer original clothing? glamor, excitement, high pay? These are all aspects of model photography, and there are photographers around the country who do this type of pleasurable work regularly.

If you are typical of most photographers, though, this type of model photography may only be a dream. Perhaps you're an amateur who sees such work as the exclusive realm of the professional, or a professional who feels he can get such assignments if he lived in such cities as New York, Chicago, or Los Angeles. And if you do live in a major city, you probably see only the high-priced "names" among professional photographers handling the bulk of these assignments and conclude that you could never join their ranks.

In fact, model photography is not limited to a handful of elite photographers. You can engage in it whether you live in New York City or One Horse Town, Iowa. Even better, you can earn money while doing it. You may not get rich or be able to earn a full-time living photographing models in small communities, but you can earn respectable financial rewards for the time involved. Model photography offers

numerous possibilities and unlimited income potential, and this book will cover every aspect of this most enjoyable field.

Fashion photography is an extremely rewarding aspect of model photography because the potential clients are so varied. Most people think of fashion photography as something that occurs only in places where you find manufacturing plants. They are used to seeing photographs of beautiful women displaying the latest designer original dresses each season; they also are aware that manufacturers regularly have photographers record models wearing their lines, and think this is the bulk of the fashion business.

The truth is that the majority of fashion photography is done outside the manufacturing centers—for department stores and clothing speciality shops in every community, for advertising, and for internal use by storeowners.

Often, fashion photography is done in conjunction with fashion shows. A photographer is hired to photograph models as they walk along a runway, displaying clothing to interested customers, or to work with individual models just before or after the runway appearance.

Another type of model photography is the preparation of portfolios. Every potential model needs a set of pictures to show to ad agency executives, photographers, art directors—pictures which show the model in different moods, types of clothing, and, often, settings. The pictures are meant to reveal the model's versatility in posing for advertisements, television commercials, and the like.

Every community is likely to have one or more modeling schools which offer potential business for the photographer. If no such school exists, you will find potential customers among high-school and college students interested in modeling, and who want high-quality photographs to take with them to a city where opportunities are greater.

Aspiring actors and actresses also need photographs of themselves, usually in different roles, and will pay top dollar for a set of dramatic poses. More important, they will want pictures whether they are currently in amateur theater in a small town or trying to break into New York's fabled Broadway.

10

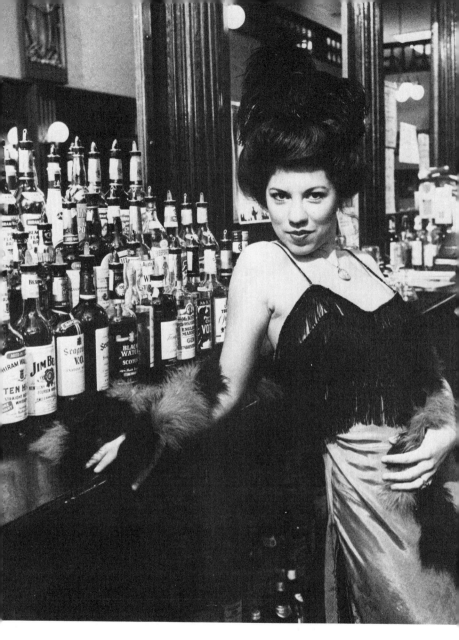

Businesses like to use attractive models to advertise their services, and models are always interested in getting as much coverage as possible. For the photo here and those on the following two pages, a model donned the costume of a Gay Nineties dancer to complement the theme of a newly opened bar-restaurant. The greater the variety of angles, the more effective and placeable the pictures will be.

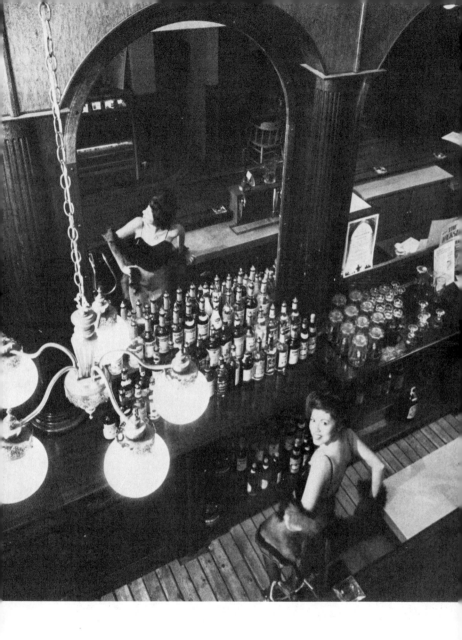

Advertising photography is another opportunity to make money working with models. All businesses like to "dress up" their newspaper, magazine, or billboard promotion with a pretty face. In other words, not only a major

automobile or cosmetics manufacturer has need of photographers. The owner of the new restaurant in town will be delighted to know that there is a local photographer who can pose one of the waitresses for an effective ad to attract the

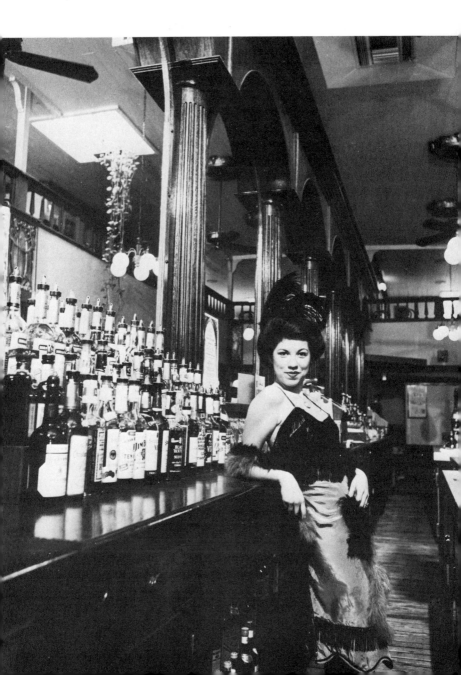

public. Or the neighborhood furniture store may want to show a handsome young couple buying the store's merchandise. Even grocery stores often need photographs of an attractive housewife for use in their ads.

The brochures and annual reports put out by businesses, hospitals, and others often carry photographs of models to break up the solid text and page after page of statistics and corporate backpatting.

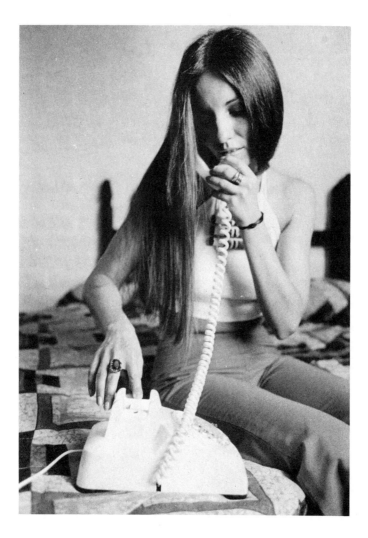

Even the simplest photos may have multiple sales potential. The photo on the facing page was part of a series taken to illustrate dealing with telephone terror for a book on home protection. It has also sold to detective-type magazines. In the photo below, a model installs a smoke alarm, also to illustrate home protection. Additional sales could be made to the manufacturer of the alarm, other publishers of material on home protection, area fire departments, and others concerned with home safety.

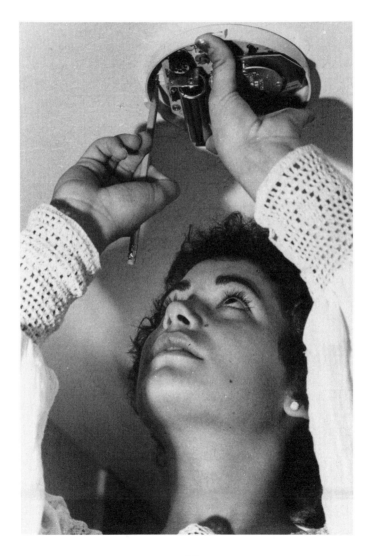

15

The magazine field is wide open for photographers who work with models. Magazines' editors buy attractive girl-nextdoor shots for their covers. This is especially true of smaller magazines with limited budgets, as well as of romance and confession magazines.

Men's magazines, both in the United States and abroad, also purchase pictures of pretty girls attractively posed. And if you photograph nudes as well, publications such as *Playboy* and *Penthouse* will be interested. The pay for such work varies anywhere from $15 or $20 on up to $1,000 or more. And what has sales appeal are those pictures which the editor feels the readers will enjoy. The money is not just paid to the elite handful of professionals who reside in the major cities and earn their living entirely from such work. If you can take an appealing photograph of a model, you too can earn a steady income from magazine work.

As you can see, the field of model photography is indeed vast. In some instances, the demand for new photographers is great; in others, in small communities, the photographer must show business owners how his photographs will increase their sales. But no matter how you work, you will find that your current location, reputation, and experience are not handicaps to earning money and having fun photographing models.

The minimum equipment you need to get started in model photography is a camera body capable of taking interchangeable lenses, and at least two different focal-length lenses. You can probably handle many jobs with just one lens, but having two offers a change of perspective which will greatly improve your work and make it more salable.

Any camera that meets these requirements will do, though 35 mm is the smallest film you should use and anything larger than roll film may limit your versatility to some degree when used exclusively. Most model photographers use single-lens reflexes, but this is not a hard-and-fast rule. You may find rangefinder equipment more comfortable because of the extreme quiet of the shutter and superior low-light focusing capability which is unmatched by almost all SLRs. Some professionals use the Mamiya Twin-Lens Reflexes with interchangeable lenses and wouldn't think of

switching to a Hasselblad, Bronica, or similar camera.

You don't need any other equipment. Certainly, owning an electronic flash unit or a couple of light stands and photoflood bulbs helps—lighting enables you to go after far more work than would otherwise be possible—but a single body and two lenses will get you started earning money. There are some ideal equipment setups, of course, but these need not be expensive, either. Professional-type lighting setups can be purchased for $100 or less. Special attachments costing a maximum of $20 can provide you with unusual optical effects, as can other low-priced items of value. But chances are that everyone reading this book has adequate hardware for handling many or most of the photography assignments suggested.

A studio is another consideration. Some photographers say studios are essential. Others work strictly on locations. This book will show you how to work on location as well as how to put together an inexpensive studio.

Knowing how to photograph models is of little value if you don't know where to find them. Modeling agencies are an excellent source, but not only are they not in every community, they also charge a fee for their professionals. These range from $5 to $10 an hour in small communities to $120 an hour or more for top models working through elite agencies in places like New York City and Los Angeles. The work you do may not warrant such an expense. In fact, if you have never sold your work before, you may not be able to afford the professional model's time.

Fortunately, there are alternatives: dancers, entertainers, aspiring actors and actresses, students. You find such people in every community, and they are often thrilled that you find them attractive enough to want to take their picture.

Knowing what to charge for your work can often pose a problem when starting as a model photographer. This text will show you how to handle this difficulty, including ways to estimate your cost and time in advance. Usually, magazines have set fees for the work they buy, but you can increase these rates by following the suggestions in Chapter 9.

Then there is the matter of the darkroom. In major

cities, a photographer can often locate one or more custom processing labs that will accept film in the morning, process it and supply prints or slides by afternoon. But in most communities the photographer must either process the film himself or mail it out of town, leading to delays.

Perhaps you feel that a home darkroom is essential because of your location, yet you hesitate because of the cost. Fortunately, the only type of model photography that would require such a tight deadline is advertising photography for use in the daily newspaper. Usually, such work is assigned on Monday when the art department or ad agency knows what merchandise will be displayed. The model is hired and the photographer shoots as early in the morning as possible. The final photograph must be in the newspaper's advertising office by the following day. If you can't deliver as required, or if you don't have the facilities to provide such service, you shouldn't offer it.

There are other considerations. You will, for example, want to know about posing, makeup, lighting, and more. These are all covered in this book. In fact, after you've read every chapter, you will know enough to successfully compete with the full-time professionals for assignments.

2

Fashion Photography

There is something exotic about fashion photography. The name alone seems to evoke images of long, lean women with haunting faces, parading across the pages of *Vogue*. Its creators are $100,000-plus per year photographers in London, Paris, and New York, and the average photographer can only dream of such work.

Yet while your work may never appear in *Vogue* and other fashion magazines, fashion photography can be very much a part of your daily activities. In fact, in even the smallest communities, fashion photography is likely to be a major source of income when you work with models. You won't be taking pictures for manufacturers and designers, in most cases, but you will be working for department stores and clothing specialty shops whose needs are constant throughout the year.

Fashion photography differs from other aspects of model photography in that the model is of secondary importance—a vehicle for selling the clothing. The model must be attractive, of course, and must enhance whatever she or he is wearing. But the viewer's eye must focus on the clothing.

The first step in handling fashion photography is to understand the nature of the garment to be photographed; for example, whether it is designed for sportswear or for an

evening in the town's most expensive nightclub, for office wear, or for an intimate, seductive dinner by candlelight. Whatever the purpose of the garment, plan your photograph so that it reflects such a use. You would not want to photograph a model dressed in a tennis outfit in an opera house, or a man wearing a tuxedo while playing on the beach.

Next consider the model. He or she should fit the image of the garment to be worn: a gray-haired woman, no matter how attractive, will seem out of place in an outfit meant for a rock concert, as will a teenager outfitted in clothing intended for the woman executive. In other words, the model's appearance should relate to the outfit.

In cities where clothing is designed and manufactured extensively, women fashion models are from 5 feet 6 inches tall to 6 feet, with the majority in the 5 feet 8 inches to 5 feet 10 inches range; their weights are proportionate to their heights and, though thin, they are never grossly underweight. Thus, a girl who is 5 feet 8 inches tall will generally weigh between 120 and 135 pounds, depending upon her bone structure, with the majority close to 120 pounds.

Models who fit these standards can wear off-the-rack garments and come close to fitting them perfectly. This is also the weight/height which designers consider when creating an original garment for a new fashion line.

In sizes, women's clothing will be either in the Misses range—6-8-10-12—or in Juniors—5-7-9-11. Many models can wear up to three sizes and will list their sizes, for example, as 5-6-7.

Outside of New York, fashion requirements are less rigid, and you will find many models from 5 feet 2 inches to 5 feet 6 inches. Since their work is for stores, the only requirement is that they be able to look attractive in a garment that is being promoted. Size is not a factor.

THE FASHION MODEL

There are three ways to get models for fashion photography. The first is through the client—manufacturer,

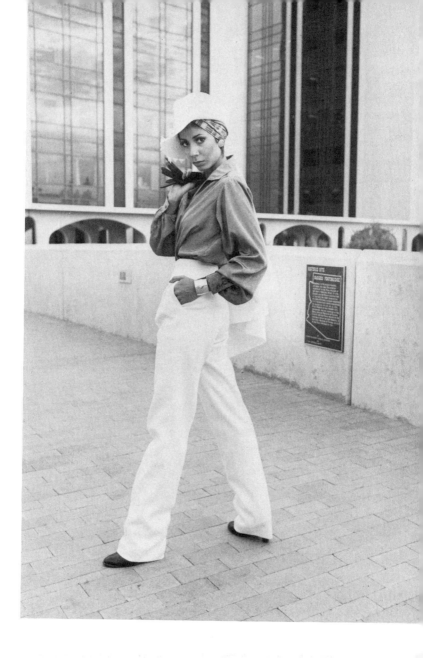

The professional model must know how to show clothes to best advantage. This three-quarters view displays all the elements of the outfit while avoiding the look of a department store dummy.

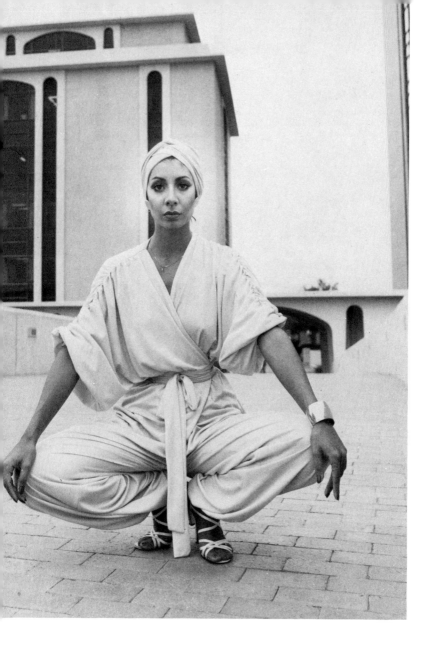

To best display the flowing lines of this exotic at-home outfit, the model assumed a yoga-like pose. The rectangular lines of the building in the background make an interesting juxtaposition to the roundness of the model's pose.

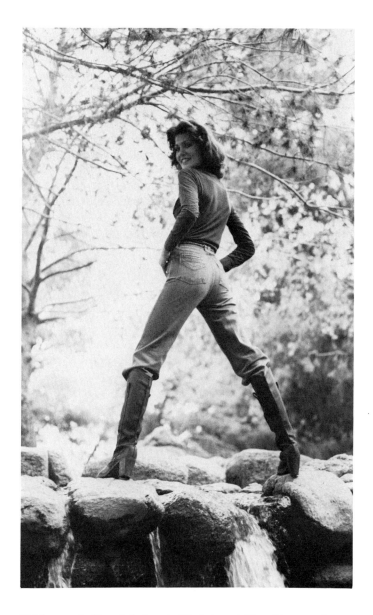

Details on a pair of jeans is the focus in this photograph. The outdoor, woodsy setting works well for this clothing shot.

designer, or retailer. The model may be on the payroll (some manufacturers employ models full-time) or just someone connected with the person who hired you. Hopefully, it is a trained staff member, a girl on the teen board who is experienced in appearing in fashion shows, or someone similar. Occasionally, it is the boss's girl friend or some other untrained, usually undesirable individual. An untrained model will have difficulty posing and, in the case of the client's girl friend, may have the wrong image entirely for the line to be sold.

The second way to obtain models is through an agency. This approach offers some assurance that the person is both trained and has a "look" appropriate to the garment. Methods for evaluating agencies and the models who work for them will be discussed later.

The third way is to select someone yourself. Although the amateur model is often ideal for many types of photography, use sound judgment when handling fashion. Since the clothing, not the model, will be emphasized, the model selected should be willing to take extensive direction on how to stand or move about so that you can capture the dress, slacks, or other garment to best advantage.

CLOTHING PROTECTION

Fashion photography places a special burden on a photographer's shoulders. The clothing being modeled will be new. It may be one of hundreds of dresses taken off the rack, or a unique designer-original dress that cannot be replaced. An outfit might cost as little as $25 or as much as several thousand dollars. But no matter what its value, the garment must be worn by the model while she poses, then removed and returned in such perfect condition that it can still be sold as new. You may be financially responsible if it is damaged, and even if the client absorbs the loss, your reputation will be injured to the point where you may never work for that client again.

When photographing fashions for a store, get one of its representatives to work with you. That person will be responsible for transporting the clothing and, ideally over-

seeing their wear. Most damage to clothing will occur when a garment is being put on or taken off. If the client sends someone to oversee this procedure, the responsibility for protecting the garment is no longer yours.

The best way to protect clothing is to plan for its transportation and use with extreme care. When working in a studio, have a dressing room where the model can put on makeup and change clothing privately and easily. If the studio is in your home or apartment, the bathroom is perfect for a changing and makeup room. In a standard studio, you should provide a small, curtained area with mirror, lights, cosmetics table, and hooks for hanging garments.

The model should put on all makeup, hair spray, and similar items while in her underwear. Makeup should never be applied when the model is wearing the client's clothing. Once this is done, the model should take a towel, place one end between her teeth and flip the other end over the top of her head, and then pull on a blouse or dress. The towel acts as a barrier between her makeup and the garment. Have the model repeat the process when removing the clothing.

Sweat shields, available from most clothing stores, should be worn whenever possible. They absorb perspiration that would otherwise stain an outfit. Although a good model will bring her own, you should keep a supply of shields in your studio. The cost is far less than the price of a new outfit.

Occasionally, makeup repair will be necessary during a session. It is all right to have the model comb her hair. However, she should remove any clothing, or be carefully wrapped in a large sheet, before a cosmetic touch-up.

When planning location work, find out what facilities will be available for changing. When you work in shopping centers, museum areas, parks and the like, there may be a restroom suitable for that purpose. However, don't leave anything behind. Carefully return all unused clothing to the car and lock them inside until needed.

Sometimes no facilities are available. In rural settings, for example, try using your car for changing. Keep a large blanket which the model can use to cover herself while changing her clothing underneath. However, this method is not suitable when the clothing is supplied by the client.

25

If you must go on location for fashion and the area has no place to change, use a small van for the assignment, even if you have to rent one. Hang curtains between the driver's seat and the back of the van and around the windows and use the back as a dressing room. Spread a clean sheet on the floor and place the garments not being worn on it to keep them from getting dirty. Remember to include the cost for the van in your charge for the photographs.

Never ask the model to do anything that may damage a client's clothing unless the client requests it and puts it in writing. This frees you from any obligation if the clothing is damaged.

PROPS

If you work in a controlled setting with lights and seamless background paper, you will find that simple props add to the effectiveness of the final photograph. A model wearing a tennis dress might be shown holding a tennis racket, for example, or an elegant evening gown might utilize opera glasses as a prop. Make sure, though, that the prop is of secondary importance in the picture. If it is a tennis racket, angle it so that only a slim profile is visible. Don't show it full front to reveal the name, as would be the case when advertising the racket and not the model's clothing.

LIGHTING FOR FASHION

Handle the lighting of the model for fashion any way you find most effective. However, remember that the fabric will need to be highlighted. Generally, this means one light used at a 45-degree angle to the subject, the light somewhat to the side of the fabric. If you use three lights—the most common lighting system—the other two are utilized for eliminating shadows.

Fashion experts often cite several rigid rules for lighting. However, you can achieve lighting success simply by moving the lights about the model, watching how the

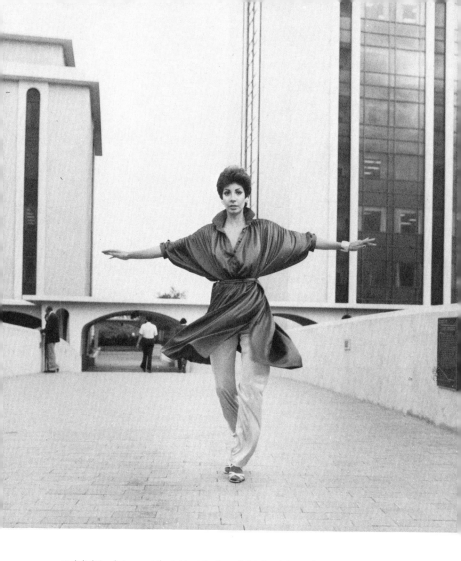

Soft lighting brings out the intricately draped details of the tunic.

appearance of the fabric changes and what shadows fall upon it. When you discover an arrangement that is especially pleasing for the particular outfit and model, use that.

27

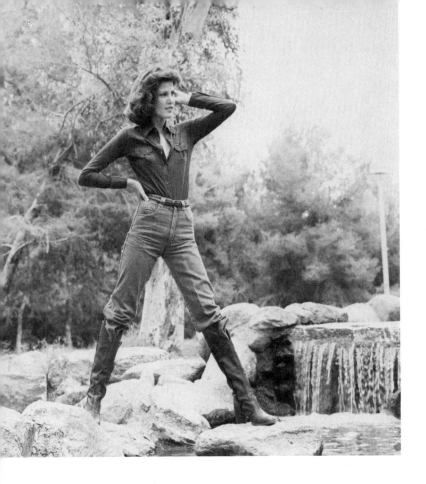

LOCATIONS

You don't need a studio to handle fashion photography; you don't even need an area in your home where you can set up seamless paper and lights. You can work exclusively on location, assuming your community has good scenic backdrops that are available to you all year.

For fashion, the best location sites are golf courses and tennis courts; indoor courts are especially good backgrounds for casual clothing, as are indoor swimming pools. Often, an area hotel will be delighted to let you use interiors and exteriors for photographs in exchange for a credit line giving their name and address.

Locations should be appropriate to the clothing displayed. If your community has particularly scenic areas or interesting buildings, you can do most of your work on location, rather than in the studio.

Keep your eyes open for interesting location spots. This tree formation was easily accessible for the model and afforded the opportunity for a number of good poses.

Museum exteriors are often quite dramatic and useful for more formal clothing. Theaters, shopping malls, and parts of airports are also good backgrounds. In larger cities, the downtown section may have old and new buildings that can be used. Sometimes fire escapes, brick

walls, and aged wooden structures with peeling paint can provide the background you seek. Get into the habit of periodically driving around to look for year-round locations. Make notes on 3″ × 5″ cards and file them under such headings as Formal Backgrounds, Winter Clothing Backgrounds, Parks, Museum Exteriors, and related categories. Write the location and description on the front of each card. If you have a snapshot of the location, place it on the back. A Pocket Instamatic type camera is useful for photographing locations for your files.

When working for a department or clothing store, you may find that you can photograph effectively inside the store. In many cases the overhead lighting will be more than adequate for black-and-white photography. If you need extra lighting, and if you select floodlights over electronic flash, be careful where you position them. Flood bulbs become hot enough to start a fire after only short use. Thus, make certain your lights don't come too near racks of clothing, wood and paper decorations, and any other objects that could scorch or burn from the intense heat.

POSING THE MODEL

A fully-trained fashion model who can assume pose after pose without direction is both expensive and difficult to find outside cities such as New York, Los Angeles, Atlanta, and Chicago. You most probably will have to direct your model.

One standard posing trick professional models learn is to imagine that they are standing in the center of a clock face. One foot bears the body weight and is placed so that when the model faces the camera, one foot is positioned at approximately a 45-degree angle from the body line to the camera while the other foot will be used for changing pose and body line. At the start, the latter foot points toward the camera, with the heel a couple of inches from the instep of the rigid foot. It is moved out so that it points from number to number around the face of the imaginary clock. It will go to the 4 o'clock position, then the 5 o'clock position, then 6 o'clock, and so on, completing a partial circle while you

photograph. Next the foot that has been moving is shifted back to bear the body weight, and the foot that was rigid is then used for pointing around the clock. At the same time, the model's shoulders are squared and the hips slightly twisted so that the weight remains on the rigid foot and hip.

There are any number of variations of these stances. The model could lunge to one side, arch her back, or lean against an object such as a wall, chair, or umbrella used as a prop. Her head could be tilted from side to side or she could be seated while positioning her legs about the clock face. She could also be kneeling or reclining, the exact approach varying in large part with the type of clothing being shown.

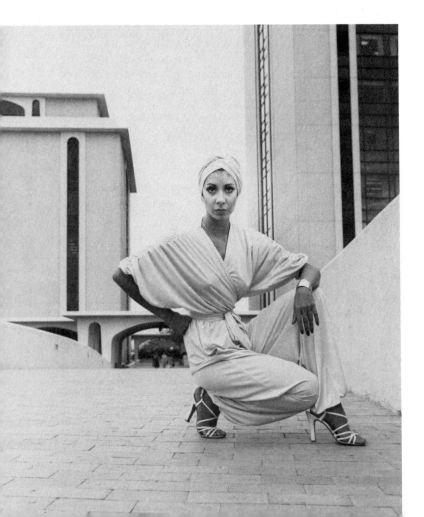

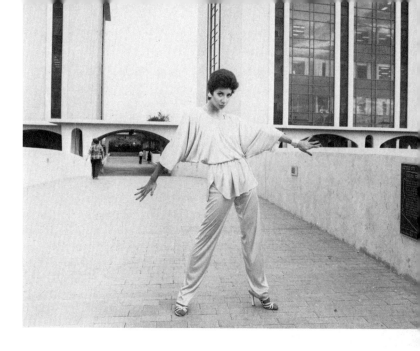

The model should be allowed to move around to find the best poses for the clothing she is wearing. At left, she has assumed a stationary pose; above, she is captured in motion.

POSING GUIDES

For posing information, an excellent source is any magazine that includes extensive fashion features and/or advertising. Many photographers clip photographs of particularly appealing poses from magazines for their scrapbooks, often devoting one scrapbook to formal wear, another to bathing suit shots, a third to sportswear, and so forth. Just before you begin, the model can study the appropriate scrapbook for posing ideas. Remember that you are not using such clippings to imitate another photographer's work, but rather as a guide for changing the model's body positions.

Perhaps the best posing guide of all is any book on ballet which shows the many positions used in that extremely graceful form of dancing. Ballet utilizes every position the body can take naturally and attractively. In fact, many fashion models have either studied ballet or taken lessons at some time in the past.

HAND POSITIONS

If the model is holding a prop, such as a tennis racket, the problem of how to pose the hands does not arise. In other cases, however, you will have to guide her. Hands are sometimes used to call attention to the clothing: a hand might be thrust into a pocket, with the thumb out over the side of the garment; or the thumbs might be in the pockets, the four fingers of each hand resting just below and the wrist slightly cocked. The model might use her hands to turn up the lapels of an overcoat, supposedly about to face a raging storm. The action seems natural and the upper part of the garment is subtly accented. Other poses include hands on hips, arms behind the back, hands clasped together, one hand resting under the chin, a hand near the face, one finger touching the lips or cheek, or arms folded. Hands can therefore be hidden or used to draw the eye to a portion of the garment.

When posing the model's hands keep in mind the accent of the photograph. A hand near the face, one finger touching the model's lips, might be fine for a picture selling a blouse or hat, but if you're supposed to be accenting a pair of boots, a skirt, or slacks, such a hand pose will draw the eye away from the most important element.

FASHION SHOWS

Many clothing stores hold periodic fashion shows. These are held in an open area of the store or in a special room rented for the occasion. Other times fashion shows are held in restaurants and tearooms, with the models describing the garment, the price, and the store from which it can be purchased as they move from table to table.

The people who stage fashion shows all share a common need—someone who can photograph them. Sometimes the pictures are only record shots for the store's files or are sent to the clothing manufacturer as proof that the show was held in order to collect a percentage. But there are times when the pictures might be used in a promotion campaign. And when a show is held during a lunch hour, the restaurant manager may need photographs to promote such

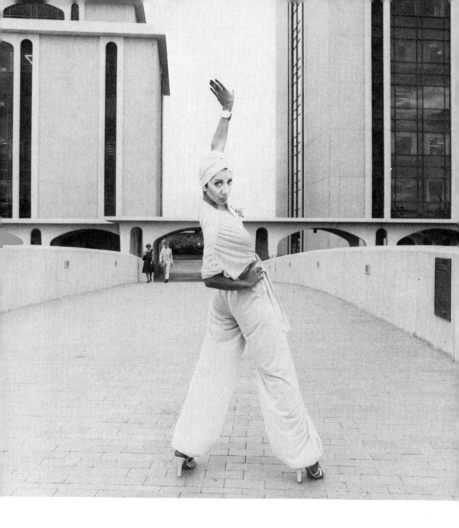

Placement of the model's hands is an extremely important factor in a successful fashion shot.

events in future. Whatever the reason, there is a large market for photographs taken by someone with professional ability.

Photographing fashion shows is much like news photography. You must work quickly, using either available light or flash. You will have little or no control over your backgrounds, though you should position yourself so that

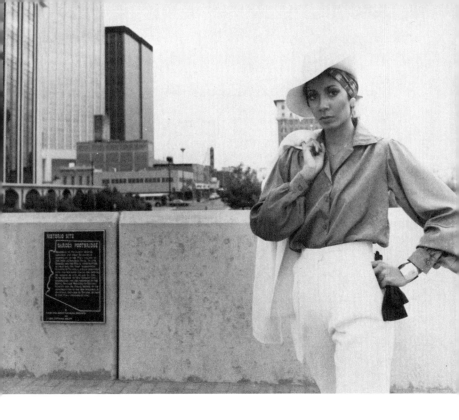

you have a clear view of the model and the outfit. If you are working with available light, there will usually be a spot on the floor where the models will pause and turn. If you can capture them at this position, it will be easier for you. Naturally, if you are working with flash, the light will stop the model's motion.

An unusual angle can help you achieve more interesting fashion photographs, for example, standing on a chair, or on a balcony of the store, and using a short telephoto lens. If the room is full and there is no way to get above the crowd, try standing in the wings, and photograph the models just as they go on or come off the stage or runway. The only problem with this takes place when the model wears multi-piece outfits, parts of which are removed as she shows the garment. You will want to catch each variation in order to have a proper record.

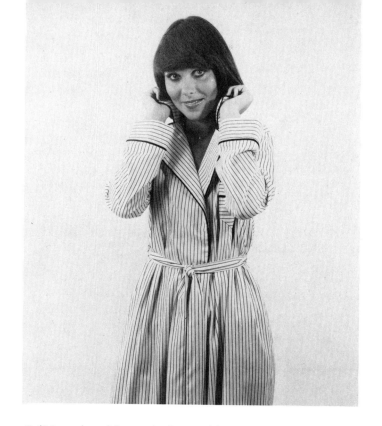

(Left) A casual pose brings out the elegance of the costume. (Above) The model displays detail in the robe by turning up the collar; it also gives her something to do with her hands.

EQUIPMENT

Before you get your first fashion assignment, start by analyzing the services you can realistically perform and the limitations of your camera. Most beginning fashion photographers use 35 mm equipment, and there is nothing wrong with this. Even a high-speed film such as Kodak Tri-X can be enlarged to a high-quality 8″ × 10″, the size print most commonly requested. Such equipment can be used for publication, fashion shows, and most other needs.

The one exception to the use of 35 mm involves color photographs for advertising reproduction. A film such as Kodachrome is perfect for advertising reproduction in that it has excellent color saturation, is easy to enlarge, and can be

printed by almost every publication despite the 35 mm size. However, it must be processed by either an Eastman Kodak lab or a custom lab that has the highly specialized equipment needed to handle this film. Such labs are relatively few in number compared with those which handle the processing of Ektachrome, a simple task which conceivably could be handled in your bathroom. By taking your Ektachrome film to a lab first thing in the morning, it can be processed, mounted, and ready for you to view by noon. However, finding a lab that can give faster than 24-hour service on Kodachrome may be a problem, and in several parts of the country, three days is considered fast service for Kodachrome.

So you may decide to use only Ektachrome. But this brings up the second problem with 35 mm cameras: the size of the slides. Many art directors and advertising people claim they can't adequately view the small slides, and few keep projectors or enlarging viewers in their offices. At best, they have a light box on which to rest the transparency. They want to be able to hold the transparency up to the light and study it with their naked eye. As a result, most insist upon 2¼" × 2¼" to 4" × 5" transparencies. Before you try to sell your work to such people, make sure they will accept the size transparency you can deliver.

Another problem with certain fashion advertising clients is the time factor. It may be that the clothing cannot be photographed before Monday morning but the slides are needed first thing Tuesday in order for the art director to meet the newspaper's Wednesday morning deadline for its color advertising supplement. A studio equipped to process color slides could meet such a deadline. However, if you have to rely on a local custom lab whose services, while extremely fast, are not fast enough to meet such a deadline, just forget the assignment.

This brings up an important point to remember, no matter what type of freelance assignment you are considering: No one loses respect for a photographer who explains that he cannot meet a deadline or is not equipped to handle a particular assignment. It is the photographer who agrees to take a job, then can't deliver the finished work on time, who will not find future jobs available. Be honest with yourself

and your potential client. If you agree to take an assignment, you must deliver the photographs in the manner promised and on time.

THE PHOTOGRAPHER'S PORTFOLIO

Your first step toward getting assignments is to prepare a portfolio containing samples of your work. This is true with every type of modeling photography you plan to do for pay. However, don't mix different types of photographs in the portfolio; in other words, nudes have no place in a portfolio that also includes sophisticated fashion poses.

Your portfolio should consist of 15 to 20 different examples of the type of work you intend to offer the client. Each print should be at least 8″ × 10″, and 11″ × 14″ is preferable. Some photographers select 16″ × 20″ prints on the theory that the larger work is more impressive, and in one sense this reasoning is correct. Unfortunately, many highly paid art directors, fashion department coordinators, clothing store owners, and similar individuals have surprisingly small office space. An 11″ × 14″ print is the largest size they can place on their desk and view comfortably from a sitting position in cramped quarters. In order to adequately judge a 16″ × 20″ print, the person may have to stand in the hall to properly view the entire image. Thus, the impressive large size may be a self-defeating nuisance in many cases.

Try to show three or more models among your portfolio prints, the reason being psychological. Some art directors will view a portfolio picturing a single model and conclude that you are unable to work with anyone else. Because you will be asked to work with randomly selected models rather than the person you photographed for the portfolio, many potential clients will feel it is safer to turn you down than risk your doing a bad job with a previously unused model. When you show several girls in your portfolio, it implies that you can make any woman and her garments look attractive.

This situation exists for models as well as photographers. If a model's portfolio shows photographs taken

entirely by one photographer, it is assumed she could not work effectively with anyone else, when in fact she probably knew or could afford only one photographer.

Color is more dramatic than black-and-white, but high-quality color prints will cost you four times as much when preparing your portfolio. So avoid color when possible. If your clients will need black-and-white illustrations, as will be the case with many advertising assignments and fashion shows, then stick with black-and-white for your portfolio. But if you want to try and sell someone on your ability to record fashion in color, then color must form a part of your portfolio.

Don't mix color and black-and-white photographs in the same portfolio; Have one color portfolio and a second one for your black-and-whites. However, if the need for both types arises and you cannot afford the two portfolios, simply separate the work in your presentation. If you have eight color and eight black-and-white prints, let the client see all eight black-and-whites first. Save the color for last. Never alternate color and black-and-white images, because the color will tend to overshadow the black-and-white. Moreover, the impact of the portfolio as a whole is greatly reduced with the alternating mixture.

Keep in mind that in a half black-and-white, half color portfolio, each type of picture must be visually powerful in the medium used. Black-and-white prints can effectively show texture and form. However, if the model is wearing a flower-pattern blouse that relies on an intricate interweaving of colors for full impact, the true potential of the image will be lost in black-and-white. On the other hand, if a blouse is white or a shirt is a solid, dark color, using color film to record it is a waste of money. Use each type of film for maximum impact.

The models you select for your portfolio can come from almost anywhere—someone in your family, a neighbor, or an acquaintance at school or on the job. You could select a professional model or else use students from a modeling school who agree to pose for you in exchange for pictures for their portfolios. How you select your models is relatively unimportant so long as they are attractive and either know how to pose or can take direction.

Good choice of location and the photographer's ability to direct a model are important selling points in a photographer's portfolio. The photo below and those on the following two pages illustrate the photographer's versatility when working with a single model and location.

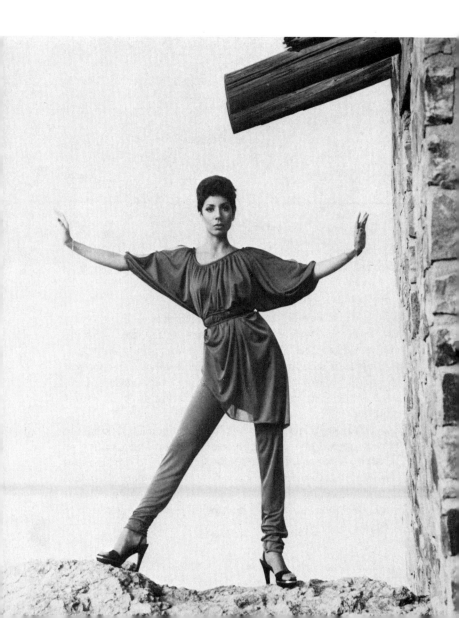

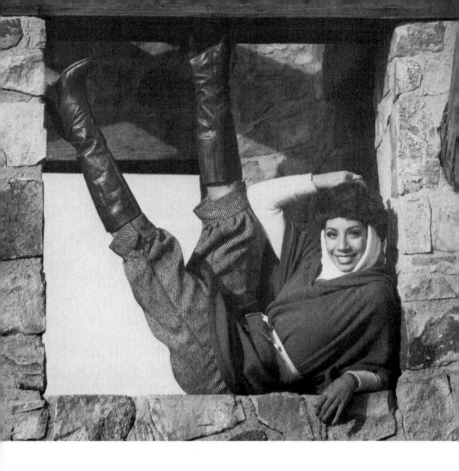

Make certain that each model has a fairly wide wardrobe. You will want her to have a formal dress, bathing suit, casual clothes, and even torn denims and a halter top. Include as many different types of clothing as you can. You should also show clothing worn during every season of the year rather than concentrating on all summer or all winter clothing.

You will have to select backgrounds for taking the photographs. Make your pictures as varied and exciting as possible. Also try for photographs that "grab" the reader and are individually pleasing. If each print is so appealing that you would enjoy having each framed and hanging on your wall, the total effect of the portfolio will be extremely positive.

When posing the model, you could show her playing in the snow or lounging by a swimming pool, depending upon the season; arriving at a theater or nuzzling horses in the woods; positioned in the midst of an abandoned group of buildings or part of a seemingly endless, rising form of an old fire escape. You could have the model riding a skateboard, playing golf, or running with a dog through the park; or let her climb a tree or dress in an elegant gown in

The photographer should be able to demonstrate that he is able to work with different angles and formats.

the lobby of a symphony hall. In other words, explore the surrounding area for different types of backgrounds, and take your models to those which are appropriate for the clothing being worn.

If you plan to offer your services as a photographer who works on location as well as in a controlled studio environment, then show examples of both types of work in your portfolio. You will find that potential clients only consider you for jobs when they see samples of similar illustrations. If every model is in an evening gown, for instance, no one will think you can photograph a girl in a bikini. And if you have only location photographs, it will be assumed you are either not equipped or unskilled in a studio-type setting.

Finally, have some business cards printed with your name, studio name and address, and information on how you can be reached during the day. If you are in school or hold a full-time job, perhaps a family member can take your telephone messages. You might also consider using an answering service or purchasing a telephone answering

If you are prepared to work in a studio as well as on location, photos taken in studio settings should be included in your portfolio.

machine. It doesn't matter which approach you use. What is important is that potential clients can reach you during normal business hours, at the very least, and that your telephone will not go unanswered. Even when a client knows you are a freelancer, he or she wants to feel that you are "established." And having a telephone that is always answered during business hours accomplishes this.

Give business cards to potential clients each time you meet them. They are a constant reminder of who you are and what you do. They make for a professional touch.

POTENTIAL CLIENTS

The best way to get your first assignment as a fashion photographer is to sit down with the telephone book and study the *Yellow Pages*. See who could realistically use your services, and make a list of names and numbers to call. Department and/or clothing stores are obvious choices, as are clothing manufacturers and designers if you live where such firms are located. Restaurants too are possible clients if they hold noon fashion shows. Many suburban restaurants hold such events, so contact them.

If yours is a convention town, then talk with hotels. Often, people in the clothing business will bring in racks of clothes, hire models to show them, and be interested in local photographers to record the session when they come into town for conventions and/or to see buyers. If your business cards are available to them when they arrive at the hotel, something the hotel manager can arrange, you will get the business.

Bridal shops are another source of potential business. There is a year-round need for pictures of brides in different styles of gowns for use in advertising and promotion.

Shopping centers too may want your services. Many malls hold fashion shows and want the events recorded. If a management person isn't on the premises, talk with store owners to learn the name of the rental agent. The rental agent can put you in touch with whomever is in charge of public relations.

Advertising agencies are also possible clients. Ask to speak with the account director and the art director. They may both be in a position to hire photographers, and they often do so independently of each other.

MAKING THE ROUNDS

Once you have your list of possible clients, start calling for appointments. Department stores have fashion directors you should see, as well as public relations and advertising department people. (Some have separate agencies working for them, to which you will be referred.) Talk with all of them.

Clothing stores generally have a manager whose duties include hiring a photographer when needed. The same is true for bridal shops. Hotels have any number of titles for people who do the same thing. These include marketing director, convention manager, special-events coordinator. Always talk with the manager's office, which will refer you.

Make an appointment to see each person. If you can't get an appointment, call every few days until you do. Some people are genuinely busy. Others want you to think they're busy. And still others have no interest in talking with a new photographer except to get the person to stop calling.

Always dress fairly conservatively when seeing a potential client. There is no reason to "look like a photographer." Many clients are turned off by an image of the "way out" photographer. So dress neatly, preferably in a suit, and you will be welcomed everywhere. Once inside the offices, let your pictures "blow their minds."

Arrive a few minutes early for each appointment. This puts you at a psychological advantage. Always identify yourself to the receptionist and explain that you are a little early for the appointment. By the time the potential client sees you, he or she has been living with the subtle pressure that several minutes have elapsed since you were announced. Instead of recognizing the fact that you were early, the client begins to feel that he or she was a little late. The person is apologetic, and your graciousness will be all the

more upsetting. The end result is that you will get greater attention and more time than if you arrived exactly at the appointed hour.

There is a sad fact of life in this business: If you don't get an assignment while you are in the potential client's office, you're not going to get one. The person may praise your work for its brilliance and genuinely mean it. But once you leave the office, chances are that you will be forgotten, your card buried forever.

This means that you will have to make follow-ups to the potential client. The first step comes within 24 hours of the initial visit. Send the person a note, thanking them for their time and stating that you look forward to handling any of their photographic needs in the future. Type this neatly on good-quality paper, preferably a formal letterhead. Include your telephone number and another business card.

If you have not heard from them after ten days to two weeks, it's time for a return visit. If you have other photos you can show, this is a plus. However, if you are limited to the same portfolio, you should still make a follow-up appointment—just to talk. Explain that you are interested in handling even the smallest photographic tasks in order to prove your worth to the person.

When nothing happens during the follow-up (again leave your card), try again in another two weeks. A gentle persistence with perhaps two contacts a month will eventually result in business, assuming the quality of your work is competitive. Breaking into a business is the hardest, most frustrating part of fashion photography. But persistence will be rewarded, so don't get unduly discouraged.

On very rare occasions, everyone a photographer contacts about assignments may turn him down, no matter how persistent he is. It is doubtful that this will happen to you, but if it does, it's time to reevaluate your portfolio. Take a good look at your pictures and try to be objective. Occasionally, you may have a subject you find so appealing that you forget to examine the visual impact of the total print. If the total image is not strong, the impression you leave with the potential client will be a negative one.

Next compare your pictures with others being published in your area. If the quality of your work is inferior,

that will be another reason for turning you down. If this is the case, you will have to redo your portfolio, adding stronger, more visually exciting images in order to compete.

Fortunately, few photographers fail to recognize poor-quality work. Most are rather insecure and tend to give themselves less credit than they deserve. If you feel your photographs are comparable to, or better than, the competition, chances are strong that you are correct in your thinking. And when that is so, getting assignments is only a matter of time.

3

Your Business Image

Because of the many misconceptions involved in the photography of models, some people look upon the entire business as being something less than legitimate. They believe that "nice" people don't pose for photographers and "nice" people wouldn't think of asking them.

In reality, however, the skilled photographer is concerned with far more than the beautiful or handsome subject posing before his camera. In addition to such technical matters as light levels, film, and shutter speeds, the photographer must consider the overall impact of the photograph he is taking. Composition, selective focus, and other problems must be handled and questions answered. For instance, do the props look right? is the clothing catching the light at the best angle? are there wrinkles which should be removed? is the makeup correct?

This is perhaps all the more so with nude photography, which involves studies in form, line, texture, and color. The body becomes a graceful object somehow separate from the flesh and blood of the actual model. Yet many people unfamiliar with this type of photography are convinced that sex is involved or that the photographer and model engage in some slightly obscene ritual which "everyone knows about" but which is never really specified.

Because of all this, it is important that you learn to handle yourself in the most businesslike manner when you want to do model photography. You must have the type of image people can trust before you will have the opportunity to take the photographs that will reveal your technical and creative skills. To establish this image, you must first form a business. This doesn't mean that you need to rent a studio, buy expensive equipment, or advertise heavily. It does mean that you should have a company name, business cards, and, if necessary, have letterheads prepared. In addition, someone must be able to answer your telephone during the hours you reserve for business, as stated on your card.

THE TELEPHONE LINK

The telephone is extremely important. It is your link with potential clients and models. Since you are calling your photography a business, people want to be able to reach you. They become wary about a person whose telephone goes unanswered during the day. Even if you only work part-time, psychologically an unanswered telephone works against you.

One solution to being "in the studio" is a telephone answering machine. You can equip one with a remote control device so that you can get your messages by calling your number from anywhere in the country. A second machine acts as a back-up when the other needs maintenance or repair. The cost for two units will be almost the same as that of an answering service handling your calls for one year.

An answering service is also useful, especially when clients are located in more than one city and you need a local telephone number in each place. But if most of your work comes from editors and publishers who utilize the mail, the extra cost of an answering service might not be justified.

A PROFESSIONAL APPEARANCE

Next you will need business cards with your company name, personal name, address, and telephone number. Such cards present a far more professional appearance than having to write your name and address on a scrap of paper each time you visit a potential client.

Finally, you must consider your appearance. You should look neat, clean, and slightly formal when talking with clients, modeling agencies, and potential models. You can wear torn jeans while you work, but when you are looking for work, a suit, dress, or good slacks outfit is important. If you live in a city where temperatures exceed 115 degrees during the summer, business suits are totally out of place for most purposes. However, you can always dress neatly when calling on potential clients or meeting new models.

MODELING AGENCIES

There are several ways to find models for the work you will be doing. The easiest and, occasionally, most expensive, method is to use a modeling agency.

Modeling agencies generally fall into three categories. There is the full-time agency which aggressively promotes the men and women listed with them. Such agencies are found in cities where there is enough advertising, fashion, convention, and similar business to warrant a full-time operation. Usually, this means major centers such as New York, Cleveland, Atlanta, Houston, Chicago, Los Angeles, or San Francisco.

The second type of modeling agency is one connected with a modeling school. When a girl is ready for professional experience, she is listed with the agency. If she has potential but needs to learn posing, makeup, and similar skills, she is enrolled in the school for training. Such agency/school combinations are frequently franchised.

The third type of modeling agency is connected with a modeling school but in a different way. The sole reason for the agency is its value as a selling tool for the school's

recruiters. The typical sales pitch goes something like this: "If you pay the $1,000 fee for our basic and advanced modeling course, you will automatically be listed with our agency. And that is the first step towards becoming a highly paid, full-time professional model."

When you start to do model work, you will have an easy time obtaining inexpensive or free models from the agency/school combinations, including those which are somewhat misleading in their sales pitches as to potential student models. The reason is that the schools like to give their new students experience before the camera. After checking you out, many of the schools will be willing to put you in touch with models who will pose for you in exchange for free prints for their portfolios. The school is happy to put a little "glamor" into the student's life, the student is delighted to save money assembling prints for her portfolio, and you are pleased to gain experience in this field.

Other agency/schools require a fee for letting a model pose for you, though it is less than that normally charged to clients. The fee may be as low as $5 an hour, one-third to one-fifth the normal minimum.

Chances are good that you will find many agencies and schools willing to work with a new photographer who has no past experience photographing models. They don't mind that you are freelancing and have no real studio, or that you cannot show portraits of models to prove your ability. All they require is that you show them a professional portfolio covering any subject. They need this to assure themselves that you can handle a camera professionally. If you can show that you are skilled with your camera, even if the pictures are of architecture or scenics, you will undoubtedly be given the opportunity to work with the agency's models.

When talking with agency personnel, have specific plans concerning the type of pictures you will be taking (Do you want to take fashion photos or product-type ones?), outfits to be worn (Will you need formal wear, bathing suits?), and locations for the photography (Do you have a studio or a place in your home where seamless background paper and lighting will be used, or will you be on location? If the latter, exactly where do you intend to take the model?).

Remember that an agency has a responsibility to the models listed with it, and none will put you in touch with a model unless it knows exactly where she is going, what she will be doing, and what pay or print trade-off arrangements will be made. Under no circumstances will an agency supply a girl for nude photographs if you are a beginner. The market for such work is too limited for anyone to try and make a living full-time in this field, so a beginner has no need for a portfolio of unclad girls. Nude models are available, generally at a higher than normal fee, for those who have already established professional sales in other fields utilizing models.

There are advantages to working with an agency or agency/school. The men and women listed with them are serious about modeling and willing to work hard for you regardless of financial arrangements; they probably have some training and are likely to show up on time, ready to work. If a model fails to show, the agency can supply someone else. However, since no-shows or tardy models seldom last very long in the business, it is doubtful that this will ever be a problem for you.

USING AMATEURS AS MODELS

An alternative to an agency is to work with amateurs. If you are just beginning, you will probably feel most comfortable approaching a friend. Or try approaching attractive strangers you meet while on other jobs.

To approach a stranger takes courage, first of all, and is something you may find difficult to do. When you approach a girl, make her as comfortable as possible. Tell her your name and that you are a professional photographer. Explain that she has an attractive face and that you would be interested in photographing her for possible use as a model. Give her your business card and tell her that if she is interested in meeting you somewhere for lunch so she can see your work and discuss modeling further, she should call you at any time. If you are married and take calls at home, tell her that if she calls in the evening, your wife may answer and she can talk with her. This will add to your

credibility and will further reduce any suspicions she might harbor.

There are several things you should not do when approaching a model. Never ask her her name. Don't ask her where she lives, whether she's married, or her telephone number. And don't ask her to decide on the spot, since "no" is the easiest decision to make when under pressure.

The reason for this approach is that it puts a girl completely in control. She knows who you are, a little of your background, and how to reach you. If you're a fraud, she can discover that fact without ever committing herself to anything and without your being able to find her again. If she decides to talk with you further, she can set the time at her convenience.

Note, too, that the first formal meeting will be in a public restaurant. She doesn't even have to tell you her name to make arrangements for the appointment. She can get a free lunch while hearing you out, committing herself only when she feels comfortable with you and your plans.

With this approach, many girls may never call. If you see others from time to time where they work, give them a card each time until their curiosity gets the best of them. Still others will call the same day. Without exception, once a girl calls, she will end up posing for you.

ENTERTAINERS AS MODELS

A third method for obtaining models is to go to area dinner theaters and other entertainment spots. Many amateur and beginning professional actors and actresses are delighted to pose. They know makeup, clothing, and have that slight touch of "madness" that makes for a delightful photography session. Talk with the theater manager, owner, or other person in charge, explaining who you are, what you need, and leave your card. The word will get around, and the actors and/or actresses interested will telephone you.

Also approach dance studios. Students at ballet and belly-dance studios not only learn body control, they also

are in entertainment fields which require them to be somewhat extroverted—exactly what you need.

PAYMENT TO MODELS

The question of payment arises when you work with a nonprofessional model. Try an initial posing session without pay, provided the work will never be sold. If the pictures are sold, you should pay a fair price, even if it is in the form of prints.

Model releases will be essential when selling your work. Always include a clause with any release signed by a model working on speculation. Such a clause states that should you sell the pictures from the session, the model will receive 25 per cent of your net fee. If you paid a standard agency hourly rate for her time, you don't pay this fee, however. It should only apply when you are both working on speculation and the model is either posing without charge or for a token fee of perhaps $5 an hour. In this way, you get talent without going broke, and the model benefits from any later success you may get from the work. Naturally, you will need to keep a model's address on file and keep in touch while you send the photographs out on speculation.

THE STUDIO SETUP

The question of whether or not you need a studio in order to work with models will arise. Most professionals have studios when they work full-time, but then they also handle a variety of assignments, some requiring models. If you work on a freelance basis, probably while holding down a job or going to school, a studio is not necessary. For backgrounds, you can use the scenic and interesting sites in your area. This is the most practical approach for the majority of part-time and even many full-time photographers.

If you want to have a studio setup without the expense of a real studio, something few part-time photographers can afford, you can create a studio in your home. All you need is an area that can be temporarily or permanently converted to studio use. There will be times when you will want strict control of lighting, background, and props, or even to create a special effect, such as a controlled breeze wafting a model's skirt or blowing through her hair; the only way to handle such work is with a studio-type setup.

SEAMLESS BACKGROUNDS

To convert part of your home or apartment into a temporary studio, simply remove the furniture in the area, take out a roll of seamless background paper and place it on special support poles, and you have your background. Then set up portable light stands, using from three to five different floodlights or a single 650-watt quartz light bounced from an umbrella reflector. Instant studio!

Seamless paper stands can be expensive—a luxury when you are starting out. The answer is to screw two metal cup hooks into the ceiling. Place them approximately one foot farther apart than the length of the seamless paper to support the weight of the roll. Next, take a long piece of thin nylon rope (the type often used as clothesline), tie one end to one of the hooks, knotting it securely, then drop the rope through the center hole of the roll of paper, pulling it out the other side. Finally, with someone holding the paper against the ceiling, pull the rope taut and tie it securely to the second cup hook. Then unroll whatever quantity of paper you need and you have an instant studio.

LIGHTING

You can save money on floodlights by buying clamp lights; these cost less than $5 each in many hardware stores. Usually, they come with a metal hood and can handle bulbs as powerful as 650 watts (normal flood bulbs are 500 watts each). You can also use gaffer tape or duct tape to tape the

light by its clamp. In this way, you can put it against walls, doors, and the like. The tape can be peeled from any surface without damaging the paint or plaster.

Electronic flash is ideal for model work but far more expensive than floodlighting. Many floodlights and stands can cost less than $100. The same amount of electronic flash equipment would cost five to ten times more. Furthermore, you will need slave units, modeling lights, and similar features for effective photography, all of which are beyond the budget of the average freelance photographer.

The one problem with floodlighting is the heat it produces. Even with air conditioning, your model will be under a strain. Allow breaks during which the lights can be turned off for a minute or two. Also provide cold beverages for the model to prevent her becoming dehydrated.

BE EQUIPMENT WISE

A word of advice about model photography or any photography from which you hope to make money: Never let your equipment get the best of you. Use the minimum equipment possible, going after those jobs you know you can handle with what you own. When you start making money, add only that which you are certain will pay for itself many times over through assignments you are sure you can obtain. Some photographers feel they have to be prepared for all possible assignments right from the start. They become equipment poor, going deep in debt from which they never recover. Using the minimum equipment possible will be frustrating at times, but you will begin making profits right from the start, and that is important in this business.

THE DARKROOM

A darkroom is not necessary. You can never charge as much for your darkroom time as you can for the time you are behind your camera. And if you aren't making any money from your work, you can use that time to seek new

assignments so profit does come your way. Naturally, using a custom lab means a time delay that could force you to turn down some assignments; however, you will find that this is far more practical in the long run. The only time a darkroom is a good idea is when it is a hobby rather than set up primarily to support your freelance model work.

4

Theatrical Photography

No type of photography is quite as delightful as theatrical work. With actors, singers, dancers, and other entertainers for your models, you enter a very special world. These people are comfortable in front of a camera, anxious to please, and willing to "perform" in such a way that you are able to record constantly changing facial expressions and body positions.

Another nice aspect of theatrical photography is that it can be done anywhere in the country. You don't have to be in New York, where live theater is a major industry, or in Hollywood, where the movie business prevails. You can live in East Skunk Hollow and still have a chance to use your camera in that special phase of model photography that is theatrical work. Of course, you will be limited to amateur companies, often connected with the local high school or college, and to entertainers who perform in small clubs where people are more interested in drinking than in listening to the entertainer. But this fact in no way diminishes the fun of theatrical photography, nor will it keep you from earning money with your camera.

Basically, there are three types of entertainers who will have use for your services. These include actors, singers, and dancers—each of which has special requirements. Actors need photographs for two reasons: to gain

61

This photograph, taken during a dress rehearsal, is effective because everything focuses on the actress's face and expression—an appropriate photo for her portfolio.

new parts or at least the chance to audition for new parts, and to satisfy their egos. This latter reason is as true of the million-dollar-a-year star as it is for Suziebelle Sunshine, the lead in the Caligula High School PTA Follies. In addition, photographs of entertainers taken during a performance can be used for advertising and promotion.

POTENTIAL CLIENTS

The first step in photographing actors and theatrical productions is to find out more about the area's potential. A few cities have resident professional companies with relatively large budgets to spend on publicity photography. If your city does not have resident professionals, discover what other types of theater offerings are available—dinner theaters, theater in the round, summer stock, amateur companies who rent an area auditorium four or five times a year in order to perform, or college and/or high school productions. In other words, explore all possibilities in your area, including theaters used by touring companies for one or two nights as they pass through town on a multi-city tour.

The *Yellow Pages* of your telephone directory is a good source for information about theater groups. Also read the entertainment pages of your daily newspaper. A call to the reporter or editor who handles entertainment may bring additional information.

Next, contact the people in charge of production. Explain that you are a photographer interested in taking photographs during a dress rehearsal or production.

EQUIPMENT FOR THEATRICAL WORK

This brings up the question of equipment. Although this topic is discussed in greater depth later, it must be mentioned here because it can interfere with theatrical performances.

CAMERA

A camera used during a stage performance must be totally unobtrusive. The entertainers are attempting to create an illusion, and the slap of a single-lens reflex mirror echoing through the audience each time you take a picture can make you very unwelcome.

So if you are contemplating buying equipment, and theatrical photography will constitute a major part of your work, get the quietest cameras you can find. At one time,

Trying to take theatrical photographs during a performance is extremely difficult, especially because the level of illumination is so uneven and because the photographer is limited in the angle he can use. This photo is extremely grainy—a characteristic of the fast films that must be used under low light conditions; it also shows the audience's heads.

this meant limiting yourself to Leicas or the Mamiya line of twin-lens reflex cameras with interchangeable lenses. Then Leitz introduced a single-lens reflex with special mirror construction which stopped the raucous sound of opening and closing the shutter. Soon other innovations followed. Today firms such as Olympus, Nikon, and Minolta offer cameras that are extremely quiet in operation. None is as quiet as the Leica rangefinder line, but they come very close and are fine for theatrical work.

If you have noisy equipment, you will be limited to two approaches: working during a dress rehearsal, or limiting your photography to noisy segments in the production. This might be a rather violent scene during a play or that part of a rock song where pulsating guitar rhythms and a driving drumbeat combine to drown out even the sonic boom of a jet plane flying directly overhead.

Dancers can often be shown best on location, because you can take advantage of more dramatic settings than would be possible in the studio.

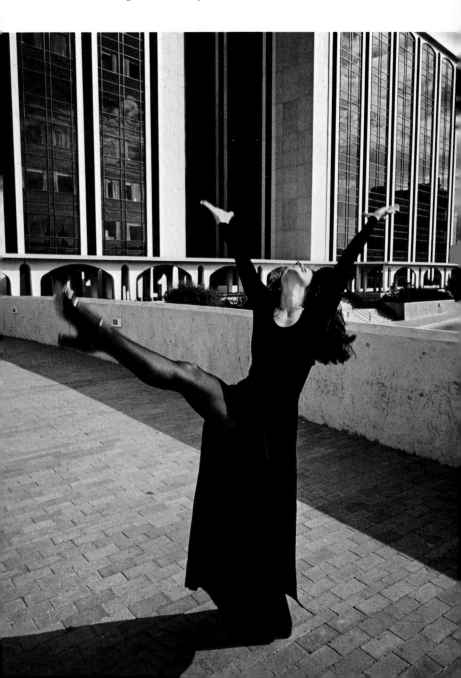

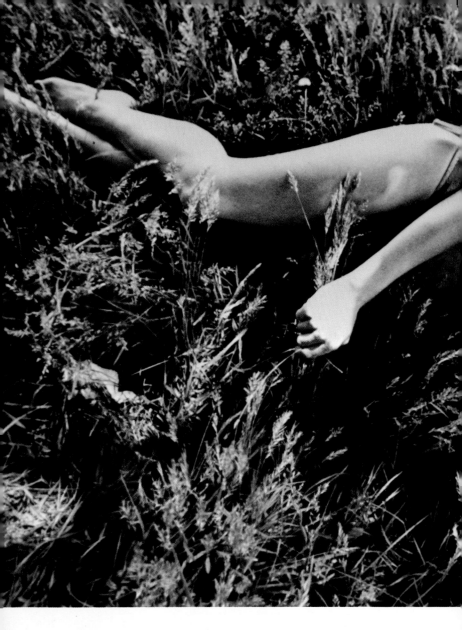

A wide-angle lens was used to photograph this bikini-clad model. The effect is certainly unusual; whether or not one likes it is entirely a matter of taste. Shots such as these should be included in a portfolio to show the photographer's imaginative use of his equipment.

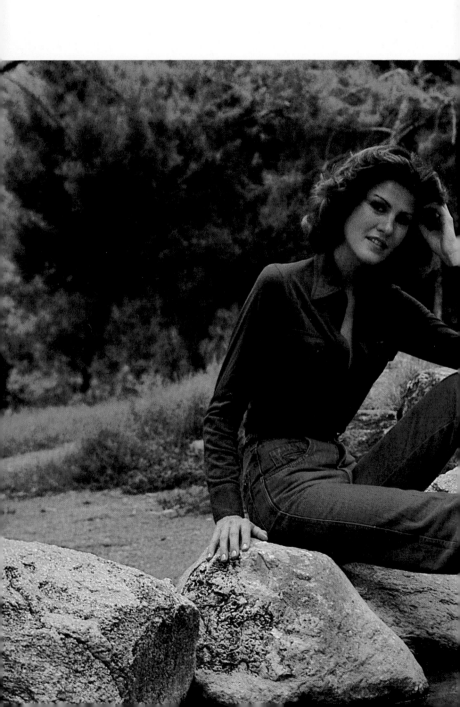

Locations should be appropriate to the clothing displayed. The outdoor, woodsy setting works well for this clothing shot.

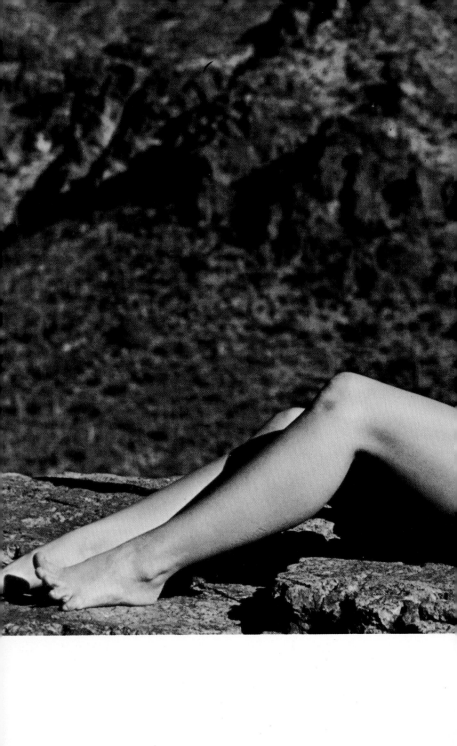

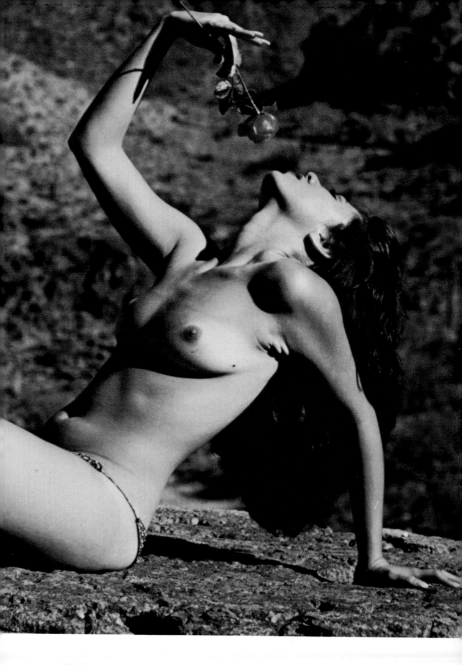

Available lighting and a natural setting provide a variety of situations for nude photographs.

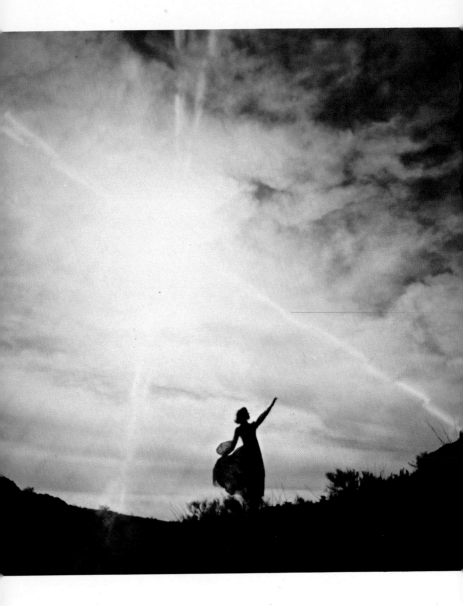

Striking cloud formations were dramatically utilized for this lovely and rather enigmatic photograph, made with a fisheye lens.

LIGHTING

Flash equipment is taboo during a theatrical performance. This means that you will have to take careful light-meter readings from wherever you are positioned. Seldom will you be able to go on stage to take an incident reading of the spotlights.

The problem with most theatrical lighting is that you have areas of strong illumination and other areas that are black. If your meter takes in too wide an angle, your negatives will be overexposed since the reading includes sections of extreme darkness. By using a 1-degree spot attachment on your meter, you can take a facial reading from anywhere in the audience or the wings. If using a single-lens reflex with built-in meter, you could try to duplicate this effect by using a long telephoto lens specifically for taking a reading. Then switch back to your shooting lens always using that original light reading.

Keep alert to changes in lighting during stage plays. Many directors utilize several levels of illumination during a production, and if you are not alert, your work could be drastically underexposed during certain scenes.

UNIPOD

One invaluable piece of specialized equipment is a unipod. Unipods can be used in areas where tripods are taboo. They can also be used to brace the camera against a wall or to add support when you have a relatively long exposure.

FILM

High-speed film is essential for theatrical photography. Generally, both color and black-and-white must be a minimum of ASA 400 for you to work effectively. If your work will only be enlarged to 8″ × 10″ or 11″ × 14″, an ASA 1200 rating for black-and-white will still provide good detail. However, increased film speed generally means increased contrast in a situation where the lighting is already of high contrast. If shadow detail is important with black-and-white, use the slowest ASA index to obtain the best image possible.

In this area, color film becomes a touchy subject. Although ASA 400 is as important with color as it is with black-and-white, the recording of that color may be a problem. Most stage lighting records best on tungsten film, although some work best with daylight film. Generally, you are safe with tungsten. But when in doubt, use daylight film, since the slight warming of the colors caused by tungsten lighting is preferable to the colder, bluish cast on tungsten film used with daylight-temperature spotlights and floods.

You may want to handle all your theatrical work with slide film because this is preferable for magazine sales. If you prefer negative color, you can have slides made for magazine work or you can submit color prints, though they are not as desirable as slides. Prints should be glossy, not the matte and silk finishes popular with many custom labs. Some magazines are totally incapable of reproducing anything but glossy images.

You can use slower than normal films in performances that have moments of stopped action. Dance is an excellent example of this. While it may be impossible to stop the flowing movements of ballet, watch for moments of peak action when movement stops. For example, a dancer might leap into the air, during which time he or she is suspended motionless. Or a male dancer might hold his female partner as she moves through a graceful dip. The low point of that dip is where she will be motionless for just a moment, prior to righting herself and continuing with the dance. By anticipating such periods, you can press the shutter so that even the extremely slow speed will be adequate to record the scene without blurring.

If you work with a slow shutter speed, there is a trick you should know. The normal tendency is to wait until the dancers or actors have paused in their movement before squeezing the shutter release. However, there is a delay between the time the scene registers on your brain and when you actually open the shutter. This delay is only a fraction of a second, but it is long enough that you may find the shutter open only after the movement has begun again. You must learn to anticipate peak action and start to press the shutter release just *before* the peak is reached. By the time the shutter is open, the performer will be motionless.

PUBLICITY PICTURES

When handling publicity for the performers, there are two ways to photograph plays. The least effective method is to work from the audience, using a wide-angle lens to record the entire stage. Such a picture, typically with the performers spread far apart, needs to be reproduced fairly large to be effective. An 8″ × 10″ print would be the minimum, and often an 11″ × 14″ is necessary for proper visual impact. Unfortunately, the realities of the publishing world do not allow for this much freedom. Newspapers and magazines fit the illustrations to available space, a variable determined by the number of advertisements and the amount of news being carried in an issue. If your work has to fit into a one-inch or two-inch hole, one column wide, and you have a picture showing all the actors on the entire stage, everyone will appear as microscopic blobs of ink when the shot is reduced to fit the space.

When you take pictures specifically for publication, you must be able to control lighting, actor positioning, and similar factors. Isolate no more than three performers interacting with each other. One or two would be better, provided that whatever they are doing represents an aspect of the play that is visually interesting.

Newspapers will want 8″ × 10″ glossy black-and-white prints. Additional prints, either 8″ × 10″ or 5″ × 7″, might be needed for hanging on the wall near the box office. Other uses for such pictures include advertising and program illustrations.

Color photographs are seldom needed for publicizing most plays. If you are working with a full professional company, as would be the case with Broadway theaters, publicity may appear in magazines that use color. Transparencies are a must in this case. Color prints can be made from the slides for wall display, but negative film is not good for magazines.

To get emotion into your staged publicity photographs, bring two or three actors together, position them for best effect in your viewfinder (normally, they are arranged on stage for best effect from the audience's perspective), and

have them reenact a segment of one of the more dramatic scenes. By watching a rehearsal of the play or reading the script, you will be able to spot the best picture possibilities.

Many photographers handling publicity for actors bring their own lighting equipment. This may be as simple as a number of clamp lights positioned on chairs, poles, and other objects, or as elaborate as multiple electronic flash units. These have extension cords all over the floor and it is easy for someone to trip on them, which can result in lawsuits.

If you bring extra lighting equipment to the theater, keep it to the minimum you will need. "Less is best" in terms of safety, providing you do not sacrifice image quality.

Next make certain that everyone in the company—cast and crew—knows when you will be taking photographs and where your lighting equipment cords will be. Try to keep the area clear of all but the people who are posing or assisting with lighting and props. This way, you will avoid accidents.

PICTURE PROCESSING

Whether or not you can go after assignments to take photographs for a play's publicity will depend upon the processing facilities available to you. If you do your own work, there is no problem. However, being your own darkroom technician is not the best idea. It is better to rely upon custom labs, using the time you would otherwise spend in the darkroom to seek new business or handle other assignments. Thus, you will have to limit your deadlines to periods which match the schedules of the custom labs.

If your city has a good custom lab for black-and-white processing and printing, find out its time schedule for processing and printing. Some theatrical companies are like the advertising departments of stores; they put off having pictures taken until the last minute—the dress rehearsal—then expect prints in quantity within 48 hours maximum. Others have photographs taken the moment costumes are ready for the principal actors. This could be from two to four weeks before the dress rehearsal, giving you plenty of time

to send the film out of town for processing if your community doesn't have a custom lab you can use.

Before accepting the assignment to handle publicity pictures, find out when they will be needed. If the time element seems too tight, see if you can do the work a few days earlier. If not, turn down the assignemnt. As stated earlier with regard to fashion photography, no one minds if you refuse an assignment because a deadline is unrealistic for the way you are equipped. However, there will be tremendous ill will if you accept an assignment and can't deliver when promised.

PHOTOGRAPHING ENTERTAINERS

Singers, comedians, and other entertainers working in clubs are easier to photograph. You can either work during their performance, taking care your equipment does not disturb the audience, or you can photograph them when the club is closed to the public. Often the lights will be turned up and you can pose the performer sitting at the piano or holding a microphone. You may even want to formalize the work by setting up seamless background paper in the club and handling the photography very much like a portrait.

For a posed photography sitting, have the singer or other entertainer wear the clothing normally worn during performance. Some female entertainers enjoy sequined gowns. These can be enhanced with a cross-star filter over the lens. (TIP: A cross-star filter breaks up spots of light into star patterns. This is extremely effective but expensive since the filter tends to run from $10 to $20 depending upon size and brand. One substitute is a 10-cent piece of scrap window screen held over the lens. The effect is identical; the prices are not.)

Amateur and "hungry" professional actors can make excellent models for your other assignments. They have a sense of movement and are relaxed in front of the camera; they usually can wear clothing effectively and are accustomed to changing their expressions frequently; and

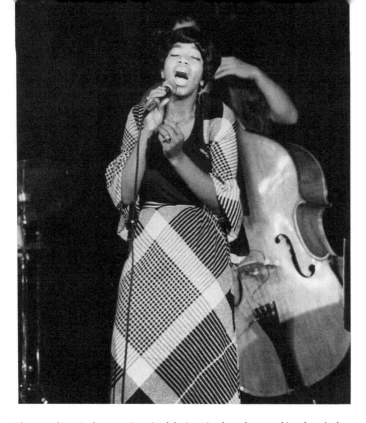

Photographing single entertainers in clubs is easier than photographing theatrical performances, for the lights can be concentrated on the performer. Alternatively, the photos can be made when the club is closed to the public, and lighting can be arranged to suit the photographer.

they are willing to work in exchange for photographs for their portfolios or a token payment when you're experimenting rather than working on assignment. Naturally, it is only fair that the model release include a clause so the actor gets paid a percentage of what you earn from the sale of the pictures. That way, if you sell from file, the actor will profit whenever you do.

SELLING THEATRICAL PICTURES

In addition to the publicity department, consider everyone involved with the production when you sell theatrical photography. Actors always need pictures for their

portfolios. If the group is amateur, high school students or PTA parents, for example, the pictures will be used for scrapbooks and family albums.

A summer stock theater or any amateur group that may use one or two touring professionals as stars in its productions has even greater picture sales possibilities. In addition to photographing the cast, everyone who participates in the production will be interested in being photographed with the star. This means sales to the people who build sets, handle props, take care of costumes, sell tickets, and handle all the other tasks involved in a production. Anyone connected with a play in a creative role is a good candidate for picture sales. They will want pictures of the production because these show their creations in use.

In addition to the publicity handout pictures you take for a theatrical group, you may be able to sell photo stories to area newspapers and magazines. A weekly paper or the locally produced Sunday supplement of your daily paper may be interested in buying a series of pictures covering the production's development. Such a series might include a picture of someone reading for a part, of the director blocking the stage, of the sets going up, a fourth taken during rehearsal, and two or three pictures showing additional facets of the production and the people involved. Brief captions will increase the amount of money you receive. This type of photo story taken for a professional company could interest national magazines as well.

Photo stories showing singers along with their backup musicians are also salable, for example, a series of rehearsal pictures showing the interaction of the group as the members work to blend their sounds.

When photographing amateur groups, you can increase sales by taking individual portraits in addition to photos of the play in progress. Simply photograph each actor and actress, in full costume, in front of the curtain, the scenery, or similar location.

PHOTO FORMATS

When photographing a picture story for newspaper and/or magazine use, always take both horizontal and

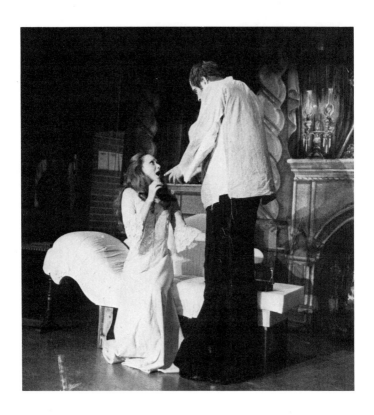

When taking pictures of a theatrical production, always have one picture that can stand alone and give the viewer a clear understanding of the production.

vertical photographs of each activity. If you use roll-film equipment with a square image, leave space at the top and/ or bottom of some photographs and space at the sides of others so they can be cropped to a horizontal or a vertical format. As mentioned earlier, publications plan space around essential news and advertising. For that reason, your work will be fit into whatever space is available. If this is basically horizontal and you supply only vertical pictures, your material will not be used. The same is true with vertical images and horizontal space. Learn to take a particular scene in horizontal and vertical formats, varying them enough so both can be used if space permits.

Always have one picture that can stand alone—a single photograph that gives the viewer a clear understanding of the production. If there is no space for additional photographs, that single image should be adequate to convey to the viewer the essence of the show.

PHOTOGRAPHY AND THE LAW

Occasionally, you may want to photograph professional performers with the hope of selling their pictures to magazines on a freelance, speculative basis. This is fine, as the law states that performers are public figures during their acts, a fact which gives you the right to sell their pictures without a signed model release. Of course, you can't make false claims about the pictures. You also cannot use the performer's picture for personal advertising or sell it in a way that implies the performer is endorsing you or any other person or product.

There are cases, usually involving professional theater groups, when you can't take photographs in the theater if you're not on specific, approved assignment. This is because the actors and actresses have a clause in their contracts which states that they must be paid when their pictures are taken relative to the show. You will find a warning to that effect in every program given to the audience attending such productions. Thus, you could be allowed to work for the theater, photographing for the group's publicity needs, but you would not be allowed to do the same if you worked on speculation from the audience.

Be careful to check the rules for any auditorium or stage area where you will be using special equipment. Although the practice is not so common today, in times past a union, such as the electrical workers union, required that a union card holder plug in and unplug all extension cords. This practice became all the more ludicrous when it triggered a walkout because someone unconnected to a production plugged in a lighting unit cord and the union members felt they had to protest this "terrible" breach of contract.

Theatrical photography is exciting, fun, and profitable. With a little advanced planning and some self-promotion, you can earn money with this type of work whether you live moments from Broadway or in an isolated small town.

5

The Model's Portfolio

Despite the women's liberation movement, the chance to be a model is the dream of thousands of girls around the country. Modeling is a glamor profession where expensive clothing, exotic locations, and high pay are a frequent part of the business, and every year thousands of teenagers and young women sign with modeling schools and agencies. Each person who enters the modeling field needs a portfolio of photographs!

Before you can begin offering your services to models, you should understand the two types of photographs models will need. Basically, these fall into two categories: the portfolio and the composite.

A model's portfolio is no different from the kind a professional photographer carries. It is a series of photographs, each of which is dramatically different and meant to show her versatility. It is a way to show potential clients what she can do and how she will look in different situations—in various clothing, with props, displaying products, and more.

A model's composite is like an 8″ × 10″ business card. It is either a single 8″ × 10″ sheet, or a 16″ × 10″ folded in half, and contains from two to perhaps six different shots of the model, her name, agency name, telephone number, and

information concerning height, clothing size, and other statistics. If she is a member of Screen Actors' Guild, American Federation of Television and Radio Artists, or any other entertainment union, that information is included. Usually, at least one of the photos is full-figure and another is full-face. If she has unusually attractive hands, lips, or legs—all valuable for jewelry, cosmetics, and shoe ads—this information is also included. The composite will be made from pictures taken when the model is preparing her portfolio but will not necessarily match those included in the portfolio.

Male models have similar needs, with the exception of photos of isolated features such as hands. Although men are increasingly used to advertise male cosmetics, both their portfolio and composite are limited to face and full-figure poses.

Ideally, a model's portfolio will show her on location as well as in a studio setting. This latter circumstance means controlled lighting and background. In a small community, you must be able to handle both location and controlled lighting settings when you try to earn money photographing a model's portfolio. In small towns, there are probably relatively few modeling jobs and little competition among photographers, and no client will care that every picture in the model's portfolio was taken by the same individual. In cities such as New York, Cleveland, Chicago, or Los Angeles, however, the portfolio should contain pictures taken by several photographers, and this can be a help to you. If you have no way to set up seamless background paper and lighting equipment in your home, you can work exclusively on location. The model can then use other photographers for the studio pictures.

According to agency directors and advertising account executives, the reason there is a difference in what is required in the big cities is that models there will be expected to respond well to any photographer. When account executives see pictures in a model's portfolio all taken by the same photographer, they wonder if that photographer is the only one with whom the model can work. They will hire models who can work with any photographer, not just one, no matter how good his work.

THE VERSATILE MODEL

There are no set rules for taking pictures for the model's portfolio. You don't have to show a photograph of her in an evening gown, bathing suit, business suit, or follow any other checklist. What you want to do is to show a model's versatility.

Perhaps she photographs best running through the woods, playing in the trees, or posing near rustic wood fences. Or she might look best dressed for a formal party, perhaps about to enter the most exclusive restaurant in town. Or she might be lounging near a swimming pool, or be photographed at a low angle through the grass. Some models are dancers and can move with a fluid grace that is a delight to behold. Others have gorgeous "come hither" expressions. It is your job to utilize the model's abilities to the fullest, never asking her to take poses that, for her, will be awkward and unnatural.

Ask her to bring along as many different changes of clothing as possible. This is essential for fashion work but also necessary no matter what type of modeling assignments she will eventually be seeking. Although her wardrobe may not be as varied for the type of modeling she expects to enter, you can assume that a girl interested in modeling will have quite an assortment of clothing.

SHOOTING SESSIONS

Before photographing a girl for her portfolio, talk with her about her interests, abilities, likes and dislikes. Learn what type of modeling she is interested in trying and what types of clothing she owns or can borrow. Then plan locations that fit her personal needs. Some girls want to include wildly sexy poses using lingerie and skimpy bikinis, while others prefer more demure attire for all their photographs. Follow their wishes, because if a model isn't comfortable with the type of clothing she is wearing, her tension will work against the success of your session.

Limit your sessions to one hour for beginners because they tire easily. No matter how enthusiastic a model might be, posing is a strain, and after an hour a beginner usually

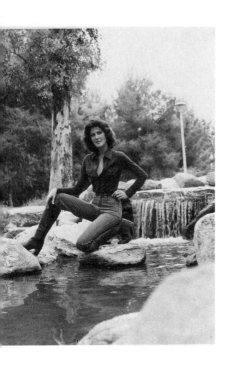

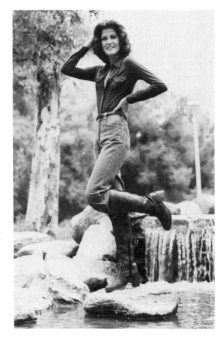

The model's portfolio should display her versatility. It should show the model in a variety of poses and from a number of different angles. This series should be supplemented with other shots showing the model in other clothing and settings, with different hairstyles and makeup.

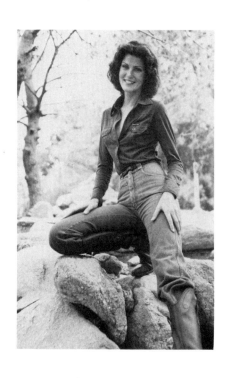

shows that fatigue in her face. The first few photographs that you take during a session will probably be discarded. A new model needs a few moments to relax and she will show less tension while you take that first roll of film. In fact, some professionals take the first 20 or 30 pictures with no film in the camera! Once the model becomes accustomed to their moving about her, pointing the camera at her face, they then load the camera. The model knows nothing about this practice and never misses the pictures she isn't shown. Start the shooting in clothing in which the model feels most comfortable. This could be jeans or a simple skirt and blouse.

MAKEUP TECHNIQUES

Most beginning models know very little about makeup. Unless they have taken a modeling course, they overapply it in an effort to "look like" a model. Makeup should be simple, not glaringly obvious to those looking at the photograph, and a basic knowledge of makeup techniques is of value to the photographer. In fact, some photographers who work regularly with models have their own makeup supplies on hand. If you should consider such a purchase, make sure you buy only hypoallergenic makeup. "Hypoallergenic" means that the makeup is formulated so that few if any women will have an allergic reaction to the ingredients. If you used standard makeup and the model broke out in a rash, she could sue you for loss of income if she had other paying assignments.

With a professional model, either she must appear to be wearing no makeup at all—the "natural" look—or the makeup must be quite obvious, stressing a color and approach that match a client's desires, as with cosmetics. Here the client will send a professional makeup artist to your studio. Even if you are taking such pictures, it will not be your responsibility to know how to apply the makeup.

A model's makeup need not be special in order to be effective. She can use dime-store cosmetics made for everyday use and still look terrific. In fact, some experts maintain that the only difference between low-cost, off-

brand makeup and the expensive type manufactured by the major companies is the price. When you buy the latter, you are paying for "prestige" and a heavy advertising campaign—not superior ingredients.

APPLYING MAKEUP

Makeup should enhance a model's appearance, not call attention to itself. Thus, it should be a color that matches her complexion. Generally, a model will start with a clean face. Using a basecoat that matches her complexion, spread it thinly over the face. The base eliminates minor blemishes and results in an even tone.

Eyes and lips are often the focal points of model photography. Focusing on the eyes draws the viewer into the picture. Focusing on the lips enhances the sensual quality of the model. For those reasons, study the model's eyes. If her eyebrow bones are prominent, these can be reduced with a small amount of gray eye shadow applied under the brow. If you do use eye shadow, it should be a neutral color and should be applied to the upper lids. Bright colors sometimes used in fashion spreads have no place in normal model photography.

A little mascara can make the lashes look longer and darker than normal, especially when constrasted with the eye shadow. If you must use false eyelashes—and it is best to avoid them—then apply the mascara to the natural lashes first. The color of the mascara is important for emphasis. A warm-toned brown mascara is effective for redheads and blondes, while black goes well with brunettes.

Eyebrows usually look fine just as they are. If the model decides to enhance them with an eyebrow pencil, she should be careful in applying it. It is all right to fill in tiny spaces in the brows, or to extend them slightly. However, if the pencil marks become obvious in the photograph, this detracts from the model's beauty.

A model wearing glasses can enhance her eyes with an eyeliner color that matches the mascara. This should be applied in a very thin line to the upper lid in order to enlarge the eye, but never to the bottom lid, as the makeup becomes too obvious.

When applying makeup for a shooting session, the first step is to apply foundation to smooth out the complexion. The foundation acts as a base for the rest of the makeup.

Blot the excess foundation so that the makeup is smooth and even.

Apply highlighter cover cream under the eyes to hide dark circles. This is essential if the model is tired, has natural circles under the eyes, or is older and has less firm skin.

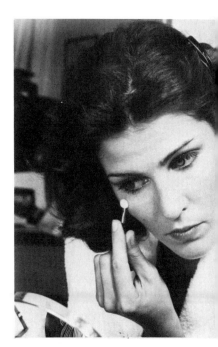

Smooth and even the cover cream with a sponge applicator.

83

Apply blush on the cheekbones, smoothing it to the temples.

Apply powder with a brush applicator for a matte finish on the complexion. The model may prefer a loose, translucent powder that is applied with a brush to avoid caking.

84

Apply eyeshadow directly to the eyelid.

Apply darker shadow in the crease over the eyelid to make eyes appear more deepset. This may be contoured to bring out the shape of the eye and to narrow the bridge of the nose if necessary.

Apply highlighter to the brow bone.

Apply mascara to the upper eyelashes, then to the lower lashes.

Outline lips with a lip pencil. This makes a uniform shape for the lips and corrects any natural unevenness.

Rouge can also enhance the model's appearance if applied properly. Most experts agree that a minimum of cream rouge should be used on the cheekbone. A thin application is worked up and out towards the scalp.

Next apply translucent powder. Lightly pat it on and brush off the excess. Never rub the powder into the cheek.

Be wary of lipstick. If the lips have good natural color, a light gloss will enhance them. If lipstick is necessary, a warm (reddish) shade is best. Remember that certain films

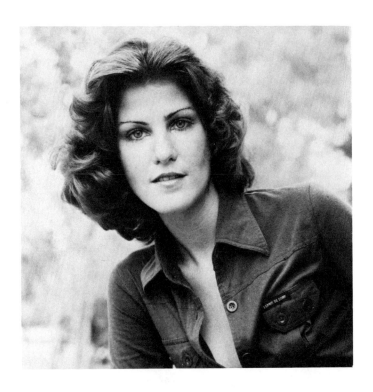

The finished look, for a casual fashion pose, looks completely natural. While more exotic looks may be desired for other occasions, the steps illustrated on the preceding pages remain basically the same.

exaggerate the color, and a thin coat of red lipstick applied to lips that are naturally red may photograph as abnormally rich in color.

If the model has minor complexion flaws, light makeup brushed over them will reduce or eliminate them for color photography. With black-and-white, you can overexpose slightly or use high-contrast lighting techniques to eliminate them. But bear in mind that you are also eliminating subtle shadings of gray which you may need for the final image.

Retouch blemishes with base makeup that is either slightly lighter or slightly darker than the natural skin color. The lighter base will enhance a particular facial feature and the darker base will hide it.

HAIR CARE

Males may also require some makeup and attention to grooming when posing for you. Haircuts should be a week old, if possible, and a man without a beard should be clean-shaven. Bald heads reflect light and must be handled carefully. Screening the light helps; so does the addition of a small amount of blush worked into the hairline of a man whose hair is beginning to recede.

Your model's hair should be soft and clean, radiating a healthy shine. Teased hair looks terrible on most models, and excessive hair spray to hold an elaborate hairdo does not photograph well. Remember that in most cases you want the model's appearance to be fresh and relaxed. Stiffly formal hairstyles or those which require elaborate pinning, spraying, and similar holding efforts will not photograph effectively. (TIP: When photographing models for your own portfolio, avoid the latest styles when possible, using girls whose hair will be as attractive and fashionable to those viewing your photographs in ten years as it is today. This will give your work a longer life in the marketplace.)

POSING TECHNIQUES

There is a technical side to posing which you should know at the outset. This relates to both camera and lighting positioning. If you are not constantly aware of the entire image as it will appear when your camera records it, you may be disappointed.

Lighting techniques will be covered in a later chapter and are the same whether you are working with fashion, glamor, or any other type of pose.

The problem of camera position arises when you concentrate so hard on the model's face that you disregard the rest of her body. Always study all parts of the image in your viewfinder. With a single-lens reflex you can study the exact scene, including depth of field, as it will be recorded on the film. With a rangefinder or twin-lens reflex camera, you will have to check to make certain the model is posed at such an angle that all parts of her body are equally distant from the lens to avoid distortion.

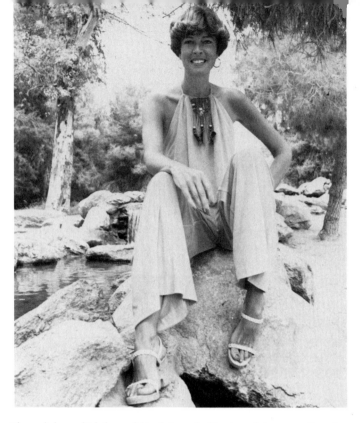

The angle from which the model is photographed is extremely important. Note that with the model's legs directly in front of her and closer to the lens than her torso, the legs and feet become exaggerated. Where the leg is on a diagonal and almost on a plane with the body, which is parallel to the film plane, the pose is quite effective.

Remember that you can always adjust the camera angle and the model's position to correct problem areas. For example, suppose the model's eyes narrow to slits when she looks directly into the camera. You can correct this by having her lower her head slightly in relation to the camera. Her chin should be tilted upward in relation to the camera to improve the appearance of a narrow chin, prominent forehead, or even a long nose. And if she has a double chin, have her tilt her chin upward.

The angle of the model relative to the camera is a factor in flattering her torso. Position her for a three-quarter or side view rather than head-on. This serves to narrow her waist and accent her bust.

90

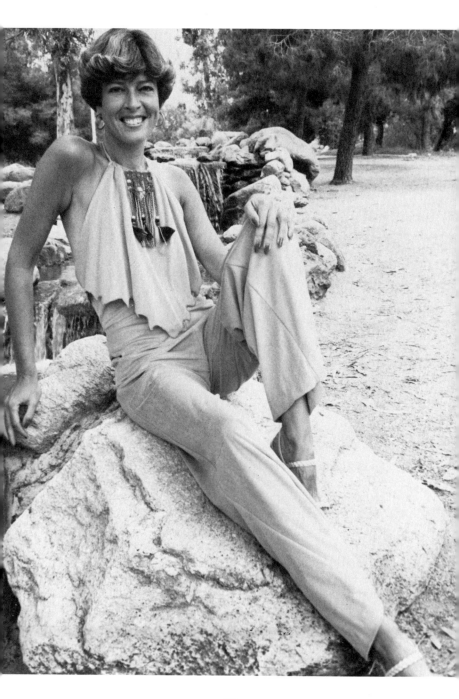

Keep the visual emphasis away from legs that are too thin or too fat. Have the model sit on her legs or tuck them under her. Heavy hips are corrected by having the model lean towards the camera, as a result of which her hips are farthest from the camera. Emphasize legs by having the model lie on her side, diagonal to the camera, her legs closest to the lens. Or she could lie on her back, her legs in the air. You will have no problem controlling distortion so long as you use a normal or short telephoto lens.

Vary the angle of your camera. Rest it on the ground, shooting through the grass (if you are outdoors), or hold it high above the model, looking down on her.

To make the model's collarbone less prominent, have her swing her arms and shoulders back behind her.

Posing for a model portfolio can be handled in the same way as for fashion. The model can use ballet movements, as well as the poses from photos you have clipped from magazines and other sources. You can also have her toss her hair back and forth, spin, leap into the air, run through a park, and engage in many other activities. Take bathing suit shots near a swimming pool. You might even show her in the water, perhaps resting against the side, smiling up at you.

PUTTING THE MODEL AT EASE

Most beginning models are quite tense when being photographed. One reason is the newness of the experience. Another is the fact that they can't tell what you are seeing through the lens, so they don't know if their poses are good or bad. Yet a third reason, surprisingly, is that models are frequently insecure about their appearance. They worry about what you are thinking about them and are concerned that you may not feel they are as good as you had hoped.

One way to counter such fears is to praise the model each time she takes a good pose. Positive comments, such as "that's lovely," or "perfect," or "I know you're going to like this one," can help put her mind at ease.

Some photographers place a large mirror behind the camera so the model can see herself as the camera sees her, enabling her to make minor posing adjustments she might

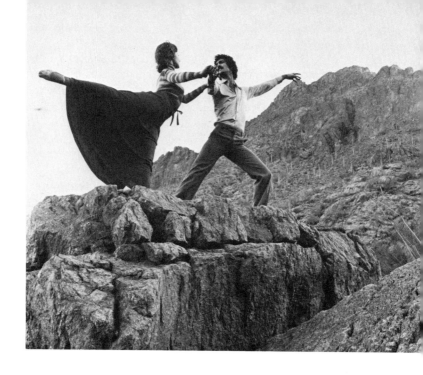

Allow the models to move about to find the best pose. Music may be a great asset; when shooting on location, bring a portable cassette player, and vary the music with the mood you want to create.

otherwise overlook. Use this technique with caution, however, as it is possible for the model to become so engrossed in a critical examination of herself in the mirror, that she becomes oblivious to you and the camera. Occasionally, you might encourage the model to look through the camera and get an idea of the final effect you're trying to achieve. This is especially valuable on location.

Another aid in posing models is to use music. Some photographers keep a variety of albums from which the model can select her favorites to listen to as she works. Others keep music which sets a mood. A dreamy-eyed model reclining on a couch during an intimate evening for two might have romantic strings playing in the background, while some rock music or even a Sousa march could set the pace for the model who must move about actively.

If you do extensive location photography, take along an inexpensive cassette player. Carry the music in your equipment case, along with your cameras. Though the music may have a tinny quality from the cheap player, it will help the model relax and get in the mood.

Always put your model at ease, even if you have to tell dumb jokes. If she relaxes and begins to enjoy herself, your session will be a success.

The first time models pose for you, a few may feel more comfortable bringing a friend along. Don't encourage such a practice, but don't refuse either, if the model will misinterpret your refusal. Too often the model is either tense with so many eyes upon her, or she is concerned with what the other person thinks. You may have mothers telling their daughters to "straighten up," or to turn their head to their "best" side, or to pull down their skirts. Models invariably listen to their mothers, usually doing just the opposite of what you want, thereby ruining the desired effect.

Oftentimes, the model looks to parent or friend for support. It is not enough for you, the photographer, to say the pose looks good. She constantly seeks reassurance from anyone else in the room. In effect, you lose control of the session, wasting everyone's time and money.

CONTACT PRINTS

After each photography session, present the contact sheets to the model for her appraisal. These can be enlarged contacts, or the standard sheets. The enlarged contacts are a help with 35 mm film. However, if the model has not hired you at a good rate, enlarged contacts become too expensive for you to provide. Or you could show her the regular contacts in a well-lighted area, supplying a magnifying glass with which she can study them.

Mark the contacts with a wax pencil, using it to indicate which shots you want enlarged and what type of cropping to make. When you no longer need the markings, use a tissue to wipe off the wax, leaving no permanent marks on the contacts.

THE FINISHED PRODUCT

The final portfolio should include examples of every type of pose the model can handle, except nudes, and should relate to available work in the area. In some communities, this will mean all fashion photographs, showing the model in formal attire, casual clothes, and perhaps a bathing suit. Include pictures taken on location and in the studio, as well as some of the model with props—purse, jewelry or similar items.

If the model is seeking advertising work, include fashion poses, but also pictures of her demonstrating products—cosmetics, toasters, ranges, lawnmowers. Show her holding products or surrounded by them, dressed in a manner appropriate for someone using the various items. Study the advertisements in magazines and newspapers to get ideas for your shots.

In major advertising centers where a new model may have to do almost anything, the portfolio should include glamor, fashion, character work, product work, and anything else that she can do effectively. Photograph in the studio, at a museum, the airport, a park, or at a playground. You need as much variety as can realistically be handled given your budget limitations and the model's skills.

Even if the portfolio will be black-and-white, and the majority are, always have color available during the shooting session. Load a second camera, when you use 35 mm, or a second back, when you use a 2¼″ × 2¼″ SLR, and have it ready. If the model proves to be unusually good, or a pose unusually interesting, you can record it in color as well as black-and-white. Then, after getting a model release, you can try to sell the color for advertising or magazine use.

Because each photograph has to be a perfect sales tool for the model, you may not have as many usable frames per roll as you are accustomed to taking. This is especially true with a beginner. This does not mean that the other images are no good, or that the photographer overshoots with the hope that something will come out right. Rather, it means that the model must strive for perfection with this work and only the very best will do. The portfolio is the key to her future, and it must meet or beat the competition.

THE COST OF PORTFOLIOS

There is always the question about who pays for the model's portfolio. Logically, the model meets all costs. She will call you and arrange a time to work with you. You will have a set rate for your time and another for the prints. Your price will include the number of rolls of film you expect to use and all processing costs. There is a markup on the prints, and you handle everything as you might if you were running a portrait studio. In small communities, this is usually the way models work with photographers for their portfolios. However, in larger cities, a barter arrangement often prevails.

THE BARTER PORTFOLIO SYSTEM

Suppose you want to have pictures of pretty girls to sell to calendar companies, magazines, stock agencies, and other markets. You need pictures you can include in your portfolio when you go to see advertising agencies and other area businesses. You also need pictures you can mail to other markets. You therefore require a steady stream of pretty girls in a variety of clothing and poses yet cannot afford the standard rates necessary for hiring them.

The answer for many city photographers is to photograph a model with the understanding that she will get free prints for her portfolio in exchange for a signed model release enabling you to sell the pictures. You absorb film and processing costs.

A variation of the prints-for-posing arrangement is to have the model pay all your expenses but nothing for your time. You donate your time in exchange for a release authorizing you to sell the pictures when and where you can.

Although technically there is no reason to offer the model any money when prints and slides taken during these barter portfolio sessions begin to sell, morally there is a question which each photographer must decide. If you agree

that the model should benefit from any money that might come your way, you can include in the release a clause stating that the model is entitled to 25 percent net income from the sale of her photographs taken during the portfolio sessions. Net refers to what you receive less the cost of making and/or mailing the single print or slide. Thus, at times the model will make more money than if you had hired her at standard rates.

ESTIMATING COSTS

Before making any arrangements, estimate your costs. A beginner's portfolio should have at least a dozen and preferably 15 to 20 photos. This may mean exposing as many as 15 rolls of film. Once you gain experience, five to ten rolls will be more typical. For 35 mm film, this means 36 exposures per roll. And if you use a 120 roll-film camera, the number of rolls necessary usually increases.

Next figure out your processing and contact printing costs. If you use a custom lab, this entails mailing expenses, including envelopes, postage, and other packaging materials. If you do the work yourself or use an in-town lab, then add travel and working time. A photographer's time is money, so you must be reimbursed for these often overlooked expenses.

One answer to the pricing problem is to work two ways. If you have a definite use in mind for the portfolio pictures you and the model will be taking, you can work out an exchange of free prints for a signed model release, with the model getting a percentage of the eventual sales. Do this with a professional model seeking a portfolio change, or with a new model who is an actress or dancer. Actresses and dancers know how to move their bodies and relate to the camera. You know in advance that their poses will be excellent and that you can probably get usable shots from the very first frame.

When the girl is lacking in special talents or just starting as a model, you can charge her normal rates for your time. There may be occasions when working with a beginner will prove a seemingly endless process because she just doesn't know what to do with herself, even when given

directions. Other times the model will be a "natural" and everything will flow beautifully. When this latter case occurs, retain the fee agreed upon at the beginning, but ask her to sign a release so you both can earn money from the pictures.

MODEL RELEASES

These are not special contracts drawn up by lawyers; rather, they are standard forms available through camera stores or mail-order houses. Most of the forms are fairly large, with ample blank space for writing in special clauses. There is also a form for a parent or guardian to sign when the model is under legal age.

Model releases are essential when selling photographs of nudes and advertising photographs. However, you can publish a model photograph without a release under certain circumstances. If the use is editorial, especially if you are publishing the pictures as an example of your work, you will not need a release. But there must be nothing derogatory in the caption material, no manipulation of the image so the published photo is different from the original, and no commercial endorsement.

THE MALE PORTFOLIO

For years the idea of a male model was a joke. Male actors found employment promoting products, but male models in advertisements were relatively few and usually limited to national accounts selling whiskey, cigarettes, and similar products. Often their sole purpose was to help emphasize the female who was featured.

Today, males are in demand to sell everything from cars to cosmetics. Men's fashions are becoming colorful and varied, with new lines introduced regularly, though still not so extensively as clothing for women. Even small communities have regular modeling work for males. It is the wise photographer who goes after this still limited but rapidly growing segment of the business.

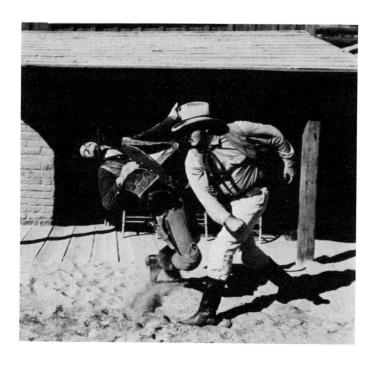

The male portfolio may be enhanced by several action shots, such as this one taken on location at an old movie lot.

There are several ways to photograph male models. One way is to work with them alone. Pose them in different clothing, perhaps engaging in activities appropriate to each outfit. You may want to work with a male and female together for some of the pictures, especially formal fashion poses. For example, you could have a picture of a couple about to enter an exclusive restaurant, nightclub, or theater. For *his* portfolio, he could be dressed in a tuxedo and standing near the building, smiling as the girl, her back to the camera, comes rushing forward in a gown, obviously a little late to their rendezvous. For *her* portfolio, you could have the same scene, only this time she is standing, smiling, and he rushes toward her. Always keep the emphasis on the person whose portfolio you are preparing.

Most of the posing techniques, including a few dance positions, work with males as well as females. Also include in his portfolio straight portraits done in the studio and in other settings.

Corrective techniques for males are similar to those used for females. While there is no great demand for less than attractive females in modeling, no matter how a man looks, he can get assignments in large and small communities. Thus, a photographer will probably have to correct for more defects when photographing men than women.

If the male model's ears are prominent, profile views offer the easiest correction. The ear nearest the camera should be in shadow, further deemphasizing it, while the one farthest from the camera will be hidden by its angle.

A heavy-set model can be trimmed using lighting techniques (discussed later). However, the use of dark clothing and the blending of the body with the surroundings also help.

Beginner models may have permanent facial blemishes or suffer from acne. Those defects which can't be hidden by makeup should be hidden from the camera.

If the model is bald, keep the camera at a low angle and avoid using a hair light, which would normally accent the hair and top of the head.

You can make many corrections by moving the camera and lighting in relation to the model. As you will learn, there is no one correct way to illuminate your subject. Certain basic lighting approaches will always provide adequate results. But the photographer producing spectacular pictures is the one who is willing to experiment with light and shadow, finding the right angle for the particular model. If this means breaking all the rules, so be it. The end result, a dramatic and unusual series of photographs for the portfolio, is what counts.

6

Equipment

The perfect camera for model photography is the one you now own. If your camera can produce 8″ × 10″ prints of high quality, you can even use the standard 126 Instamatic. Admittedly, most model photographers use fully adjustable cameras, usually with interchangeable lens capabilities. This broadens their horizons and enables them to be more versatile. But so long as you do not try to take photographs that are beyond its capabilities, you can use just about any camera.

Few if any photographers ever have all the cameras and lenses they want. Everyone dreams of one day adding a different format or some specialized lens(es). If you work with 35 mm, you may want a 2¼″ × 2¼″ SLR or a 4″ × 5″ view camera. If you own a 90-degree wide-angle lens, you fantasize about one that will take in 180 degrees. If you have one camera body, you want two. Or perhaps you want a power winder or a motor drive. Every variation in your equipment means new ways to see and new images to record. But you will never be free from the "I wants," and you shouldn't put off tackling model photography just because you don't own what some big-name glamor photographer owns. The photographer who masters whatever he or she possesses will turn out beautiful, salable pictures on a regular basis. Without that mastery, all the

exotic equipment in the world will not bring you success.

If you don't now own much equipment, or if you're planning to add a different format, you may want some idea of the different cameras and lenses that are most apt for model work. However, if you lack such cameras and lenses, you can still sell your services within the limitations of those items which you possess.

CAMERAS

The type of camera equipment you need will depend upon the markets you want to reach. Color fashion photographs for newspaper advertising supplements generally have to be handled either with roll film or 4″ × 5″. These transparencies are large enough and can be studied without magnification. Most department-store art directors are hostile to 35 mm not because the newspapers have problems reproducing it, but because it is so hard to study without a projector.

Freelance work for magazines does not require such large formats. The 35 mm size is perfectly acceptable, and most publications are willing to look at 8″ × 10″ color prints, provided they are printed on *glossy* paper. Textured surfaces cannot reproduce effectively.

Most likely you have at least a 35 mm camera with adjustable lens. It may be a fixed lens rangefinder type or an interchangeable-lens SLR. Neither the age nor the brand of the camera matters, and even image quality is not crucial. A slightly soft lens is often considered an asset with glamor work. In fact, some photographers shoot all their glamor pictures through a skylight filter that has been smeared with a thin layer of Vaseline to soften the image.

LENSES

Whatever type of camera you have, you must recognize its limitations and concentrate only on those photographs you can take with it. If you are dependent only upon the lens that came with the camera, know how it can

be used; for example, you probably will not be able to take effective closeups of a model's face due to the apparent distortion caused by moving in with close-up attachments. However, these same attachments are fine when photographing a ring on the model's hand, a necklace against her bare chest, earrings dangling from her lobes, and similar isolated shots that show only a portion of her body.

A single lens limits you in a studio setting too. You may not be able to move back enough for a full-figure shot of the model, by using the normal lens that comes with most 35 mm cameras. For this you will need a moderate wide-angle, such as the 35 mm on a 35 mm camera, or a 50 mm on a 2¼" × 2¼" camera. Thus, if you only own a normal lens, in the studio you will have to content yourself with photos in which the model is sitting or where only a portion of her body is photographed. Once outside, there is always room to move back.

Use a moderate telephoto lens for isolating a model's head. Moving in close with the normal lens creates apparent distortion; her head appears to balloon slightly and she seems to gain weight. The image can still be attractive, but only with careful angling of her head and control of shadows.

If you ever have to move in close with a normal lens and you want to minimize distortion, you can use the model's hair to sculpt her face. Assuming your model has long hair, either her own or a natural-looking wig, let it hang down the side and photograph her in profile or partial profile. Move the hair down the cheek so the slight ballooning effect caused by the close lens is not apparent. The hair will be slightly distorted, but this goes unnoticed. The viewer subconsciously assumes the hair is full-bodied and does not see the unusual puffiness as distortion. The distortion is only evident if the picture shows the model's cheek.

QUALITY LENSMOUNTS

The type of camera you own is unimportant in model photography; so too is the brand of the lens. Private lensmakers using computer-designed optics offer extremely

high quality equipment for very little money. You sacrifice nothing in image-taking ability by buying a $50 Nothingflex 135 mm instead of the $300 Moneyflex 135 mm made by your camera manufacturer. The optical quality will be almost identical.

The main reason one lens costs six or seven times more than another of the same focal length and f-stop is the quality of the construction of the mount. A state-of-the-art lens by a major manufacturer will probably last a lifetime despite continued abuse, during which time the mounts will function flawlessly, the alignment will never vary, the screws will never need tightening, and the entire lens system will handle as well as the day you bought it.

On the other hand, the typical life for a private lensmaker's equipment is approximately five years when subjected to intense usage. The pictures they record during that span are usually impossible to tell from those taken by the more expensive equipment. However, the less expensive lenses simply can't take the same abuse for the same period of time.

Once you have the three basic lenses—normal, moderate wide-angle, and short telephoto—you can handle any type of model photography. Of course, the greater the variety of lenses, the more images you can create. For instance, ultra-wide-angle lenses let you show unusual perspectives, while extreme telephotos help you compress distances, change relationships, and give the model a different image. But such equipment is a nice luxury, not a necessity.

EQUIPMENT LIMITATIONS

For all these reasons, you can see that the minimum equipment for working with models should be a camera with a normal, moderate wide-angle, and short telephoto of approximately 2× magnification (85–105 mm lens on a 35 mm camera, for example). This will enable you to work inside or out, regardless of space limitations. With only the camera body and the lens that came with it, you narrow your potential so much that there will be relatively few

professional services you can render to either the model or a client.

If financial reasons make ownership of more than one lens impossible for you, then don't seek general assignments. Rather, you should photograph models on location for sale to them for use in their portfolios, and to magazines that need pictures of pretty girls. You take the pictures and send them out on speculation. You will not be able to handle advertising assignments, though you could sell single pictures from file to advertising agencies. You will also not be able to handle fashion shows since you may not be able to stand back far enough to photograph the entire outfit the model is wearing. If this is your predicament, use the profits from the work you do get to save for the equipment you will need in order to handle glamor, fashion, and other model work.

THE BASIC PROFESSIONAL KIT

After buying the three basic lenses, try to purchase a second body, perhaps used, to fit your lenses. This will enable you to switch from black-and-white to color and will provide you with a back-up camera in case one is damaged.

Motor drives and power winders are luxuries which many photographers lust over but never purchase. They are ideal for capturing a dancer's leap or a model running across a field. However, you can get along well without one. The better models listen for the camera click before moving. Each time they hear it, they change their pose and hold it until the next shutter click. Their faces retain an animated quality even though they are standing still for a second or two while you manually advance the shutter and recheck your viewfinder. If you want a motor drive or winder, buy it, but not until after you own the three lenses and two bodies, which comprise a versatile, basic professional kit.

LARGE-FORMAT EQUIPMENT

Purchase larger-format cameras the same way as 35 mm. The same rules apply, though if the camera you

select has interchangeable backs, such as the Bronica or Kowa, you will probably want two bodies as well as two or three backs. Having one body and two backs allows you to switch from black-and-white to color but does nothing for you when the camera shutter jams or otherwise needs repair. You need the ability to switch to a working second camera so you can continue taking pictures.

The only time when a truly large-format camera, such as a 4″ × 5″, can be of real value is when you're trying to sell stock photos to magazines, calendar companies, and others. A few publications prefer the large-format transparency. However, such equipment is so slow to operate and so limiting on location that you aren't likely to make enough sales to warrant buying it. A full professional studio handling architecture, advertising, and general commercial photography can make good use of such equipment, but even then it isn't essential. So many sales are possible using 35 mm and 120 roll-film equipment that the 4″ × 5″ is truly a luxury you should not try to afford.

SUPPORT EQUIPMENT

These should include a sturdy portable tripod and either a unipod or a shoulder pod. A good-quality tripod generally retails for $50 to $75. Such a unit will be collapsible, able to extend to approximately six feet in height, and sturdy even when totally extended with the rising center column. If the unit is adaptable to a dolly, that is a nice extra but hardly necessary. What you want is a tripod sturdy enough so that it can be fully extended outdoors in the wind and still enable you to take sharp pictures with slow shutter speeds.

Unipods cost between $10 and $25. All that really matters with such units is that you can place a camera on the fully extended unipod, press against it for sturdiness and have it stay rigid. Poor-quality units tend to sink slowly to the ground because the locks for the sliding leg extensions are not sturdy. Fortunately, price does not always reflect quality, and some very inexpensive units are also highly reliable.

The top-of-the-line unipods have one or two special features which may make them more attractive. One feature is a modified panhead. The camera screws into the unipod and can then be twisted about, locked into any position, while the unipod stays rigid. A second feature found on some units is a support base. The tip of the unipod unscrews to reveal three short metal legs. These are unfolded and the top screwed back into the unipod. The legs are thus made rigid on the ground and the unipod becomes free standing. This is nowhere near as sturdy a support as even a poor-quality tripod, but it does give you greater sturdiness than might otherwise be possible.

Neither of these additional features is necessary, however. If you have no special need for them, you can cut your cost in half by staying with the conventional models.

LIGHTING EQUIPMENT

When you think floodlighting, think in terms of threes. A basic studio lighting setup will have a minimum of three floods which can be used for main light, fill light and hair light. Sometimes these are of different strengths and are placed an equal distance from the model. Other times three identical-wattage bulbs are used, but the fill light and hair light are kept farther from the model than the main light. Obviously, the more lights you have, the more versatile you can be.

The two types of lights you can buy are standard photofloods and quartz lights. Standard photofloods are rated at either 3200 K or 3400 K. In theory, tungsten films respond best to the 3200 K lights and Kodachrome indoor film responds to the 3400 K. The fact is, you can mix the two with no problems. The slight additional warmth when using 3200 K film with 3400 K bulbs, and the slight cooling when the reverse is used, are unnoticeable.

PHOTOFLOODS AND QUARTZ LIGHTS

Standard photofloods begin to wane the moment they are used. They slowly darken, losing approximately 100

degrees K color temperature for every certain number of minutes they are on. This means that your pictures will change color as the bulbs age, and a color picture taken at the start of the bulb's life will be different from one taken just before the light fails from age. However, this is one of those problems which in practice does not prove to be very serious. You can work just as well with an old bulb as a new one, though your light readings *will* be different. The darkening bulb means less light is hitting the subject than is the case with a fresh bulb used at the same distance.

Quartz lights are far more expensive than photofloods and also far superior. They cost eight to ten times more money on the average but have a longer life (75 hours vs. 6 hours maximum for a photoflood) and constant color temperature without blackening. They are the ideal lights if you can afford them, though the holders are more expensive.

Generally, you can save money by buying quartz lights in sets of three, complete with accessories such as barn doors, which are opened and closed to varying degrees in order to control light output. If your area dealers offer nothing in your price range, one reliable source of mail order lighting is Spiratone, Inc., of 135-06 Northern Blvd., Flushing, New York 11354. Their best line of quartz lights comes in a kit for less money than other dealers charge for similar equipment. However, the Spiratone lights will still cost around $400.

Photofloods can fit into any screw-base socket, and this capability enables you to save money. You can buy clamp lights to hold them. These consist of a clamp handle and silvered reflector, available from camera and hardware stores, and some department and discount stores. They can handle up to 650 watts safely but you may prefer to use 500-watt photofloods. These clamp lights cost as little as $5 each and last for years with normal care.

CLAMP LIGHTS

You can attach these to special stands (again Spiratone is a source if you can't get them locally). You can also clip them onto doors, the backs of chairs, stepladders, and almost any other object with a sturdy, not too thick side

or back. For extra precaution, use either masking tape or Gaffer's Tape (also called Duct Tape) to hold the clamp in place. Filmmakers use them to hold lights against walls. The tape peels off any surface smoothly without leaving marks.

REFLECTORS

Reflectors are an essential part of model photography. By bouncing the light off a reflector, you can fill shadow areas in the eyes, bring out details in clothing, and otherwise improve the overall lighting of the model.

The most versatile reflectors are silvered umbrellas. Reflectasol is one of the major brand names, though other manufacturers make such equipment, often at widely varying prices. If your dealer doesn't stock them, try Spiratone.

Umbrellas can be attached to normal light stands, with the floodlight or flash bounced off it. This greatly reduces shadow problems and diffuses the light for a softer effect. Some light intensity is lost but not enough to be a problem. Umbrellas can also be used alone to reflect existing light into the model's face.

Blue-colored reflective umbrellas convert tungsten light to daylight, so you can use daylight film indoors with tungsten floods bounced off the umbrellas. Gold umbrellas add warmth to your images. There are also white and black umbrellas, the latter being used to absorb extraneous light which might otherwise cause harsh contrasts of light and shadow. These are especially useful in bright sun when you position the black umbrella between the sun and the model.

You can make your own inexpensive reflectors. One way is to take a stiff, lightweight board, such as Balsa wood or a piece of corrugated cardboard, and cover it with aluminum foil. The foil can be smooth or crinkled to give slightly different effects. Or you can use a heavy white card, perhaps attached to a lightweight board or piece of corrugated cardboard, to reflect light. Art supply stores are good sources for this material.

FLASH

You will need electronic flash on location, especially for fashion work, though you need not worry about having

one for a studio setting in the beginning. Flood bulbs give far more light for their cost than electronic flash. The flash is cheaper to operate and cooler for the model, but the initial outlay is so high for even inexpensive systems, and the amount of light so relatively limited, that you are better off starting with floods. You need only a single flash for location fashion photography, though you will get better results with two, not to mention having an additional back-up unit. These can be relatively low-powered units in terms of light output.

TIP: When using bounce light, you can turn a single electronic flash into "two" units by placing a rubber band around the flash head to hold a white index card at the top of the head. When the flash head is pointed toward the ceiling, the card will reflect a small portion of the light straight into the face of the model. The main light bounces from the ceiling, giving a soft, even illumination, while the card adds a fill for all shadow areas of the face.

BACKGROUNDS

The materials you use for backgrounds depend on you and your budget. You can use cup hooks to suspend a roll of seamless paper from the ceiling, or you can buy sturdy stands from which to suspend the paper.

Some photographers use a large expanse of white wall for backgrounds. Others work strictly on location. Generally, it is best for a beginner to buy the minimum equipment necessary, so work on location if you can do so. If you must have a studio-type setting, then buy seamless paper, but think long and hard before buying stands as well.

Thus, the chances are great that you have everything you will need to begin handling model photography and earning money with your camera. If you must add additional equipment, or if you want to expand beyond that which you own, go slowly. Certainly, the more you have, the more versatile you can be, but there is no sense in getting swamped needlessly with overhead. With a little careful planning, even the most meager budget will be adequate for your needs.

7

Nude Photography

Studies of the human figure have been a part of the art world for centuries. Artists have always looked upon the rendering of the body in oil, charcoal, stone, and other media as one of the greatest challenges they could undertake. As a result, our museums are filled with paintings and sculptures depicting naked and partially clad men and women.

Photographers are artists too, the difference being that they utilize cameras and film rather than brushes and paint to capture their visual insights into the world around them. As artists, it is only natural that they be attracted to the subject that has long appealed to painters and sculptors. In the case of model photography, this means working with nudes.

Today, many types of nude photographs are published, and unless you understand the marketplace, it will be difficult for you to move ahead. At one extreme is the pure-art nude in which the body is but a design element: breasts may be isolated and photographed to look like mountains, or buttocks like a rolling landscape. So much attention is paid to the pure form of the body that it is totally depersonalized. One has to study such a photograph closely to even recognize that a naked man or woman is the subject.

At the other extreme is what some people consider pornographic—photographs of the body that accent the

sexual aspect of the person; at their worst, the camera angle is extremely low, thereby emphasizing pubic hair and genitalia. Such pictures are generally sold through "adult" bookstores and less reputable businesses.

Between these extremes are the vast majority of nude studies being produced by photographers. These are pictures which range from the pretty, unclad girl-next-door, which *Playboy* made famous, to the attractive girl on a calendar, to the figure studies in photography magazines and books aimed at an audience interested in the fine arts. Sometimes the nude is shown in silhouette. Other times the body line is emphasized through the use of a dance position. Still other images focus on the girl's smiling face, the fact that she is wearing little if any clothing being of only secondary importance. The model is recorded as an attractive person or as part of the design element of the overall photograph. He or she is not depicted as a sex object or distorted for the purpose of pure art.

THE FINAL PHOTOGRAPH

The problem with most nude photographs taken by beginners is that little or no thought is given to the final photograph. It takes so much nerve to ask someone to pose, that little consideration is given to what will be done after the person consents. Thus, typical first efforts often show the model on a bed, a living-room chair, or another location where one or two lights can be used and privacy maintained. The only distinguishing element in such attempts is the fact that the model is nude.

Before taking nude photographs, first consider the final result you want to achieve. Photographs taken for male-oriented magazines generally must follow a theme. These magazines like to show the model as someone who just happens to be undressed in several of the poses. They want to show her doing things, interacting with others, or engaging in activities that can be portrayed in a visually interesting manner. Some photos might show her in shorts and a halter top, jogging with her dog early in the morning, or romping on the beach in a string bikini, or dancing in a

tight-fitting dancing outfit at an area disco. And a few might show her topless or fully nude, carefully posed against seamless background paper or other controlled surroundings. The pictures reveal not only her good looks but also something about her personality, interests, and the way she spends her time.

Photographs taken for photography magazines and similar publications should stress the overall image. The layout of each photograph, lighting techniques, props, and other details are just as essential as the appearance of the model. Often, the body line is used as a strong design element. Whatever the case, each single image must be capable of standing alone and being enjoyed for its uniqueness.

Calendar companies and other users of nude photographs seek pictures that can stand alone. They want an attractive picture of a wholesome-looking woman with a pleasing smile and a good body. Her nakedness adds to the visual appeal, but sex is not stressed. In other words, they want the pretty girl-next-door-who-happens-to-have-all-her-clothes-off type of picture.

LOCATIONS

If you live within driving distance of an isolated beach, wooded area, desert, or mountain terrain, you already have locations for your photography. Scout around to see where you could effectively work with a model and still have privacy. If the area is a well-traveled one, try to pick a spot from where you can see anyone approaching before the person sees you. This way the model can cover herself and not be embarrassed by the passing stranger.

Old buildings where you can work with either available or artificial light make attractive settings for model photography, as do abandoned cabins, old sheds, and other dwellings. Often, these are surrounded by thick weeds, shrubs, and other foliage, providing natural cover. But make certain that the area isn't so loaded with greenery that the color of the plants is reflected onto the model. This can drastically alter skin tone if the final photograph is in color.

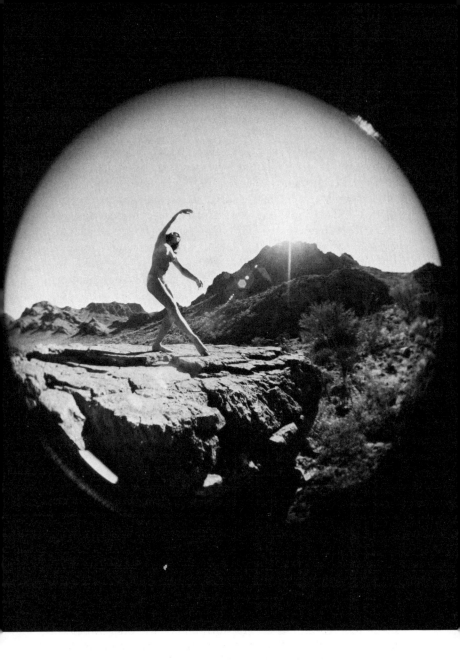

A fisheye lens was used for an unusual effect in this location shot. With nude photography in particular, try to vary lighting and equipment as much as possible. Photos such as this have almost unlimited markets.

114

The easiest approach to nude photography is a studio-type setting using seamless paper for background. You don't have to worry about trespassing on private property, watching out for passers-by, and you don't have to worry that your model will be arrested for indecent exposure. However, you will be limited to the body positions and few props you can artistically arrange in the confined space the seamless-paper background offers.

FINDING MODELS

If you've never worked with models before, don't expect to start with a nude, the one exception being a spouse or lover who is willing to pose for you. This latter arrangement is usually unsatisfactory because it is often difficult to maintain the psychological detachment necessary to produce quality nude studies when working with someone with whom you have been intimate. You are better off working with a more casual acquaintance, difficult as this may seem at first.

MODELING AGENCIES

The most obvious way to locate nude models is through a modeling agency. Every large city has a number of agencies that list models who are willing to pose in the nude for professionals. The same is true with many agencies in smaller communities, though not to the same degree. There are some communities—fairly isolated—where "nice" girls just don't pose without at least a two-piece bathing suit.

Before contacting a modeling agency about hiring a nude, put together a portfolio of photographs illustrating the quality of your work—photographs of models, scenics, advertising work, sports, whatever. Include 15 to 20 of your best prints, black-and-white or color. Mount these in an album or portfolio case with clear plastic pages. Then take this portfolio with you each time you make an appointment to see any agency director.

Pay attention to the way you dress for such appointments. A more formal attire will add to your professional image.

Explain to the director what you have in mind, where you will be working, and what you will pay. Show examples of previous sales, if any. If you are considering a definite market, name the publications involved. Also name the editorial people connected with those publications who will be seeing your work. This too adds to your credibility.

Most modeling agencies will arrange for you to meet with one or more models in their offices. In a community where $25 an hour is high modeling pay, expect to pay $35 an hour for a nude model.

When talking with the model, again show your work. Be ready to explain what you want to achieve and your requirements. These might include a knowledge of fashion poses or perhaps ballet experience. Be able to explain what the model will be doing, where she will be doing it, and what the ultimate outcome of the work will mean in terms of potential publication.

Agency directors don't care if a photographer is a working professional or just getting started. What they want to see, is that he can produce professional pictures. If his work isn't professional, they won't allow their girls to pose nude for him.

FINDING MODELS ON YOUR OWN

If you can't work through an agency, you may be able to get people you know well enough to pose for you. Failing that, try talking with strangers, though this is more difficult.

One answer is to use as your nude models, people in artistic professions, as they are likely to understand the aesthetic nature of nude photography. This means actors, actresses, dancers, even artists and art and photography students. People who work in exercise clubs and health spas also make good models, as they are likely to have good bodies and muscle tone.

Never ask anyone to pose for nude photographs the first few times you work together. When the model comes to trust your attitude toward photography and your ability with the camera, only then discuss the possibility of nude photos. At this point in your relationship, if the model likes your work and feels comfortable with the pictures you plan

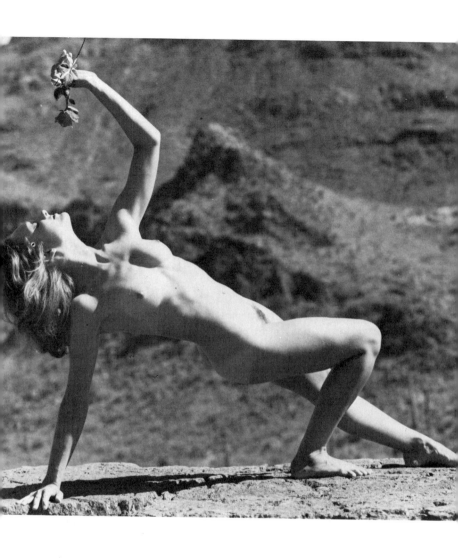

Use strong lighting to bring out contours of the model's body.

to create, the decision will be based on a personal moral code and not on a concern over your intentions. If the model is not interested, he or she can still pose for you while fully clothed.

WORKING WITH A MODEL

Show your nude model every respect when working. Have her bring a robe or loose dress that she can wear when there is a break in the action. Better yet, keep such a garment near you, just out of camera range, and toss it to her whenever there is a pause.

Never have the model undress or dress in front of you. If there is no room where she can change, try to find a satisfactory substitute. On location, you could keep a blanket in the back seat of the car, and the model could cover herself with it and change clothing underneath.

Discuss with her the poses, location, and the effect you want to achieve with the nude photograph before she undresses. If you use a cross-star filter, fisheye, or other optical device, explain this to the model as well. This is especially important with a distorting lens, like the fisheye, which requires a pose that is enhanced by the curvature.

Never deviate from your planned posing session without discussing such changes with the model in advance. Having told a dancer to move about in a certain way, it may be upsetting if you suddenly tell her to touch parts of her body and look "sexy."

NUDE COMPOSITION

Nude photography requires close attention to detail when composing the image. When a model is fully clothed, a slight lens distortion may go unnoticed. With a nude, however, that same angle may exaggerate the model's hips or thighs, adding apparent weight and resulting in a distorted image.

Before releasing the shutter, study the image in your viewfinder. If you use a wide-angle lens, try to keep the model on a single plane, with all parts of her body equidistant from the lens. If she sits so that her hips are closer than her legs, the hips will seem several pounds heavier; and if her feet are closer than her torso, her leg will look oversized.

Look for any blemishes—birthmarks, vaccination scars, surgical scars. Also look for those red marks which appear when part of the model's body has been pressed against a rock or other hard surface. If overlooked, the final print may be unflattering or require retouching.

Silhouettes can be extremely attractive with nudes. Try such work early in the morning when the sun is at a low angle, or, in a studio setting, by concentrating all the lighting on the background. Take your light-meter reading from the sun or the background paper and use this for your basic exposure. Then gradually open the lens one ƒ-stop at a time to add details in the model.

Caution! If you're using an older light meter or one built into an older camera, it probably is a cadmium sulfide. This type of unit can be "blinded" by exposure to the sun or other harsh light, a situation which does not occur with selenium and silicon blue cells. If you must take a second reading after the exposure to harsh light, wait ten minutes to ensure accuracy the second time around.

Light and shadow are more critical with nudes than with a clothed model. If the sun is filtering through trees and creates a pattern of light and shadow on the model's clothing, it will probably be unnoticeable. However, the situation is quite different when the model is nude. Since the flesh tone is continuous, a pattern of light and shadow interrupts the natural tone of the body. When such a situation occurs, you could try to work with the pattern for a pleasing effect.

Props too are an asset with nude photographs. A large floppy hat, flowers, or other object the model can wear, hold, or make use of in some way, will enhance a photo. The same is true of unusual furniture.

Makeup can hide blemishes but must be applied with care. Since the photograph will show a large expanse of flesh tone, makeup that doesn't match skin color will detract from the final photograph.

Make your model feel at ease while she is posing nude, and say positive things to reassure her that she looks fine. A model is always nervous during a photography session, and even more so during a nude session.

Eye contact, or the lack of it, can be extremely

important with nude photos. If you're working for form, don't let the model look directly into the camera as this personalizes the image. On the other hand, if the model must be a personality, it is essential that most of the pictures show the model looking into the camera.

On location, experiment with the model running across the wide open space, leaping into the air, hanging from a tree, and otherwise carrying on as though she were having a delightful time being naked and free. Shoot from different angles or use a slow shutter speed with panning action. Let the model's body become a design element rather than the total focus of the work. The greater the variety of images, the greater your chances of selling your work.

Nude photography is challenging, enjoyable, and quite beautiful when handled properly. By carefully planning background, props, and posing, you will achieve images that you can frame for your wall or sell for publication.

8

Lighting

A subject of great debate in model photography has to do with proper lighting techniques. Professionals talk about Rembrandt lighting, butterfly lighting, and numerous other approaches. Many schools teach certain basic lighting techniques from which their students never deviate. As a result, many photographers are needlessly concerned about what should be a rather simple procedure.

The key to lighting is to make the model look his or her best. If the subject is the model's clothing, as with fashion photography, then the clothing is of primary importance. How you handle the lighting will vary according to the equipment available to you, the specific subject, and your own creativity.

All "rules" about lighting evolved from the manner in which early artists utilized the sun. For milleniums the earth's primary illumination has been that single light source traveling across the sky. Early artists utilized this light source in their studios, painting their subjects so that one side was heavily illuminated and the rest in shadow. With the introduction of floods, portraiture followed the same general principles of sunlit artist studios.

121

THE STANDARD SETUP

Today, a typical lighting setup for studio use will have a minimum of three lights: one light, the strongest, will highlight the face; a second will fill in the shadows; the third will illuminate the hair, molding the head and separating it from the background. If the lights are all the same wattage, they are placed at different distances to the subject in order to vary the light intensity.

Some photographers are moving away from the three-light setup by using instead one powerful light that is bounced off a large umbrella reflector. The umbrella softens the light and produces an effect that seems to smooth the skin and reduce minor blemishes in the final print. The only problem, so far as the beginner is concerned, is the cost. A high-powered flood with sturdy stand and large umbrella generally costs more than the three-light system of inexpensive screw-base flood or tungsten bulbs.

LIGHTING THE MODEL

When a model photograph fails because of lighting problems, chances are that the photographer failed to observe the model to see where light and shadows were falling *before* releasing the shutter.

First turn on one light—either a tungsten bulb in reflector holder or a light bounced from an umbrella—and direct it toward the model. Keep the light so that it is either at face level or slightly above. Study the way the light falls on her face, and watch for shadows in or under the eyes and nose, and at the side of her face. Also, be on the lookout for what seems attractive and what seems to give her a harsh, fat, or otherwise unpleasant appearance.

Take the light and begin walking around the model. Carefully observe where the shadows fall as the light angle changes. If you have trouble working this way, shift the light stand a few inches, then stand at the camera position to study the effect. Go forward to shift the stand some more, then return to the camera position. Examine the effect of the light from every angle of the model's head until you find the one that is best for her face and the mood you are trying to create.

Lighting can make all the difference in a model's appearance. In the photo at left, harsh shadows filtered through leaves give an unpleasing effect. For the photo below, the model moved slightly and the shadows became softer and more flattering.

Next, take a second light, either less powerful than the first or of the same power but slightly farther from the model, and use this to fill in shadow areas. Again manipulate the light for best effect.

Use the third light to highlight the hair. A very strong hair light, placed directly behind the model's head, will produce a halo effect. Reducing the intensity will result in a pleasing sculpting of the hair.

You can obtain a single, soft overall light by bouncing a flood or tungsten light from a large umbrella reflector. This is extremely flattering to most models and helps reduce facial lines and minor blemishes.

ELECTRONIC FLASH

If you can afford electronic flash units of reasonably high light output, be certain they come with modeling lights so you can envision their final effect. Position the units with the aid of the modeling lights—usually 25-watt bulbs— much as you would with floodlighting. When the units flash, their light will strike the model in almost the identical manner you anticipated with the modeling lights connected to them.

The least-expensive electronic flash units with auxiliary modeling lights have a holder to attach the modeling lights directly on top of the flash. The better flash units have the modeling light built close to the flash head so that reflectors, barn doors, and other accessories can be utilized to previsualize the final effect.

REFLECTORS

With available light, some of the foregoing lighting techniques still apply. However, instead of using floodlights, use reflectors for your fill- and hair lights. These can either be pure white reflective boards mounted on a lightweight frame, boards covered with aluminum foil, and/or silvered umbrellas. They can be mounted on stands, propped against a tree, or held by an assistant. If your camera is mounted on a tripod, you can even hold a small reflector with one hand. If the model is lying in the grass, you can prop a white reflector against a rock so that it reflects enough light into the model's face to eliminate the harsh shadows caused by the sun.

You can make your own reflectors by using aluminum foil to cover 11″ × 14″ and 16″ × 20″ pieces of corrugated cardboard salvaged from photo mailers. Or you can purchase canvas frames and stretch taut white cloth across, stapling it to the edges. You can also buy reflector umbrellas. They are an unnecessary luxury though admittedly a great convenience.

TYPES OF LIGHTING

The illustrations throughout this chapter show the many ways a single light can create varying effects when allowed to "travel" around the model's head. Thus, the following information should prove helpful as a guide to basic lighting.

REMBRANDT LIGHTING

This technique is so named because it duplicates the way the artist Rembrandt painted sunlight falling on the face of many of his models. When applied to photography, the camera faces the subject and the light is positioned at a height above the subject such that the angle from light to subject then back to camera is 45 degrees. The light itself is positioned so that it is 130–160 degrees from subject to camera. This light illuminates the hair, forehead, and one side of the nose, mouth, and chin. Depending upon the angle of the subject's face some light may spill over into one eye.

45-DEGREE LIGHTING

A second technique is 45-degree lighting. Once again the light is positioned so that it is slightly higher than the camera. This time a 45-degree angle is formed from light to subject to camera. A second 45-degree angle is formed by drawing an imaginary line from the subject's forehead to the light stand, and a second line from the top of the light to the face. The effect is a strongly lighted face with no shadows under the eyes or nose.

Lighting from one side only throws the other side of the face into complete shadow. This can be remedied by use of reflector on the unlighted side of the face.

Harsh, raking light will bring out all the imperfections of a model's complexion.

Backlighting, or rim lighting, when used alone, will produce a complete silhouette. Used in conjunction with frontal lighting, it adds a lovely halo effect to the model's hair.

So-called "hatchet lighting," or 90-degree lighting, is seldom of use in regular modeling work.

Rembrandt lighting illuminates the hair, forehead, and one side of the nose, mouth, and chin. The light is positioned slightly above the subject.

Fortyfive-degree lighting produces a strongly lighted face with no shadows under the eyes or nose.

BUTTERFLY LIGHTING

A variation of the 45-degree approach, one that does create shadows, is butterfly lighting. The light is positioned so that it strikes the face fully but at such an angle that a tiny shadow is formed by the nose on the upper lip. A slight shading of the eyes also occurs. This is also known as glamor lighting.

With butterfly lighting, pay careful attention to the model's makeup. A heavy shadowing of the eye with a color that is darker than her skin tone will be unpleasantly exaggerated by the shadow created by the light itself.

PANCAKE LIGHTING

One of the least flattering ways to lighting most models is to place the light next to the camera and illuminate full face. The light is at the same height as the face, so it completely lights the front and throws a harsh shadow on the background. This is known as pancake lighting and tends to flatten the face. It also adds weight to the face, a problem that is exaggerated with a wide-angle lens.

90-DEGREE LIGHTING

A variation of pancake lighting is 90-degree lighting. If the camera is pointed so as to catch the subject full face, the light will be placed to the side, positioned so that the angle from light to subject to camera is 90 degrees. One side of the face is harshly lighted; the other side becomes a black shadow. The face is sliced in half, as a result of which this technique is also descriptively termed hatchet lighting. This is great for monster movies and as the first step of a lighting technique that utilizes additional fill lights. However, it is seldom of any value with normal modeling work.

RIM LIGHTING

Another type of lighting is called rim lighting. The light source is positioned behind or to the side of the model at such an angle that only the barest outline of the face is illuminated from the camera angle. A variation of this produces the halo effect on hair. However, with rim lighting, a single bulb is used for the entire illumination, so it must be positioned to allow some light to fall on the face.

LIGHTING COMFORT

No matter how you light, think about the model's comfort at all times. Using tungsten or floodlighting is a way to "slow cook" the model. After a few minutes under several bulbs, each emitting 500 watts or more, the heat buildup is tremendous. Try to work in air conditioning when using floods. Also give the model a break away from the hot lights.

Have plenty of cold liquid refreshments available. Working too long under intense lights can lead to dehydration.

SAFETY PRECAUTIONS

Your extension cords should be heavy-duty ones. A thin cord can cause a fire. So can overloading an outlet. Plug the lights into several different circuits, putting no more than 1,300 watts on any one, even though each circuit is designed for 1,500 watts. If you have a coffee maker going, however, you will have to reduce the wattage of flood bulbs plugged into that same outlet.

Never put a larger than normal fuse in a fuse box in order to accommodate the lights on one circuit. This increases the chance of a fire.

Keep a five- or ten-pound fire extinguisher handy when working with floodlights. This precaution is meaningless more than 99 percent of the time; however, the heat from these bulbs is so intense that if one should accidently come into contact with seamless background paper, the paper could burst into flames.

All these precautions may seem unnecessary and most likely they will be. However, if you don't expect the unexpected, you won't be prepared for a problem should one arise. Since you will be liable for anything that happens to the model as a result of your carelessness, thinking about safety when working with hot lighting equipment is essential.

9

Selling Your Model Photographs

Photography is an expensive pursuit. Once you own a camera, you must constantly purchase film to "feed" its insatiable appetite. Add to this the cost of either a commercial processing lab or your own processing supplies, and you have a situation where it makes sense to find alternative methods for paying the bills. The most logical way is to let your model photography pay for itself through the sale of your pictures. Surprisingly, this is much easier than you might imagine.

PRESERVING NEGATIVES AND SLIDES

First it is important for you to know how to store your pictures prior to selling them. The best model photograph is of no value if it is lost in the midst of 10,000 other negatives and slides carelessly tossed in desk drawers. Even if you can find the picture easily, improper storage over a number of years can result in fading.

BLACK-AND-WHITE VERSUS COLOR PERMANENCE
Most photographers recognize the relative permanence of the black-and-white image. As evidence, photo-

graphs taken before the Civil War remain in excellent condition today. Thus, the quality of your black-and-white negatives should be such that 50 years from now you can take one of today's pictures and duplicate it exactly from the original negative. Archival processing—the processing of film and prints for long-term storage—is offered by some custom labs.

Color is another matter, because the dyes are unstable. In the Kodak line, for example, Kodachrome is the only color film currently available that stands an excellent chance of surviving your lifetime. With proper storage, Kodachrome slides should last a minimum of 50 years without noticeable color change. This means storing them at room temperature with 40 percent humidity.

Most Ektachrome films have a life span of just five years, the exceptions being Ektachrome Slide Duplicating Film 5071 for Process E-6, and Extachrome Duplicating Film 6121. These are potentially as stable as the Kodachrome line. Interestingly, the stability of dyes in slides that are projected is better with the Ektachrome Films (Process E-6) than it is with Kodachrome.

STORING SLIDES

Slides will discolor and/or fade if exposed to too much light. For this reason, avoid projecting any slides which you intend to sell; use a magnifying viewer instead.

Store slides in the dark; this does not mean in a darkened room. You can keep them in special plastic pages designed to hold twenty 2″ × 2″ or six 2¼″ × 2¼″ images. These fit into a notebook which, when closed, keeps the pages of slides pressed loosely together and provides adequate darkness. No direct light falls upon the pages until you remove them for viewing. These holders are available through most camera dealers and are excellent protection when mailing the slides as well. Most of these holders are heavy-duty and can take rough handling for years. Avoid the "bargain" ones, though. You may want to buy slide holders in quantity. A number of companies manufacture them and advertise in such photography magazines as *Popular Photography* and *Modern Photography*

You can also store slides in special trays, boxes, and similar devices. These are all adequate but inefficient. If you use projector trays, the slides must be projected for sorting, and this means possible deterioration. Special boxes require you to remove the slides individually for study, and this extra handling can damage them.

Not only can the slides be readily sorted with the plastic sheets, they are also protected from fingerprints and other marks. You simply hold each sheet up to the light and view from 6 to 20 images at once. Dust can't reach the slides and coffee or soft-drink spills can be wiped clean, usually before the liquid has a chance to seep into the pocket holding a slide.

Ideally, slides for long-term storage should be carefully packaged in watertight containers then stored in the freezer. This practically eliminates image deterioration and adds to their life.

MAILING SLIDES

When you have a negative, you can make a print from it many times over. With a slide, it is the original that gets sent to the possible buyers. If anything happens en route, your original is lost forever. To protect these originals, some photographers insure their slides at the post office each time they mail them to a potential buyer. They set a value of several hundred dollars each and feel secure that they can always collect the insurance. Unfortunately, insuring something for a set fee does not mean that you will get paid the same amount in the event of loss.

In general, the post office insurance program requires you to prove the typical value of a slide if you claim it is worth more than the material cost. Saying that you sent your slides to *Playboy* that they were for the centerfold, and that you would have received several thousand dollars for them isn't a valid claim. It is fine for the photographer who has sold pictures to *Playboy* in the past. It may be that you are submitting on speculation and have never sold any of your model photographs before. Thus, you cannot put a value based on the magazine's rates because there is no guarantee

the magazine would have accepted your work.

The typical post office insurance claim is settled by paying you the fee you normally receive for the work you were mailing. If you are new to this business, you will only receive the cost of materials, no matter how much money you spent for coverage.

INTERNEGATIVES

An alternative approach is to make an internegative. This should be at least 4″ × 5″ to accurately duplicate the quality of the original. The internegative is a negative made from your slide, which can then be printed or made into a new transparency. Its long-term storage capacity is limited, however. The internegative's value is in letting you retain a copy of the original image should the slide be lost or damaged.

Internegatives are fairly expensive, and the relatively minor cost for duplicate slides still adds up quickly when you mail hundreds of slides out each year. One solution is to take several exposures of the same image whenever possible—in a sense, making your own duplicates as you work. This is easy with a model who has been told to hold each pose until she hears several clicks of the shutter. It is only when you're working with someone such as a dancer, that a duplicate slide or an internegative might have to be made to obtain extra slides of an image that was too fleeting for more than one exposure.

Keep in mind that certain fast-moving subjects can easily repeat their movements in the identical manner. Ballet dancers, for example, follow a rigid form for their movements, and they can make a leap over and over again in exactly the same manner and at exactly the same spot if you so desire. Just tell the dancer what you want and you can make as many duplicate images with your camera as you need.

Store slides according to a system that fits your needs—by topic, for example. Each notebook can contain images relating to a specific subject. This can be general, such as architecture, or more specific, such as Guggenheim Museum. Whether or not you use one general topic or

several subtopics will depend on how many slides you have of any one building, person, or scenic, and how great the demand for those images might be.

When it comes to model photographs, have a notebook devoted entirely to nudes, another for dancers, a third for nightclub entertainers, a fourth for theater groups; others might be broken down by the name of specific models. You could keep fashion photographs with others of the same model, or break them down according to types of clothing. All will depend on the topics you're most frequently called upon to send to publishers and other clients.

STORING BLACK-AND-WHITE NEGATIVES

These are stored differently. Let a custom lab contact-print every roll of film if you don't own a darkroom. Today, the time that you would have to spend in the darkroom could be more profitably spent taking pictures. Darkroom time would actually cost you money, and the custom lab charge is a relatively minor expense, so let them do the job.

Use plastic holder for both the strips of negatives and the contact sheets. File two contact sheets, back to back, in a plastic page protector, then follow this with two plastic holders, each containing the negatives from one roll of film. Place these in a three-ring notebook and number the sheets in sequence, placing corresponding numbers on the appropriate negative holders. Use a black pen with indelible ink that can write on plastic, and place the number on an edge that is well away from the negatives. Be careful not to get ink on the negatives.

Finally, make 3″ × 5″ cards detailing what is on each frame. The number of cross references you make is a matter of personal taste. You might be a photographer who tries to cross reference by every conceivable possibility, making it easy for you to find the selection. However, others limit themselves to just a single card containing the model's name.

When you prepare a black-and-white print for mailing, stamp the back with your name and address and

Careful storage of contact sheets and negatives is essential. Above is shown the Paterson system of negative filing. At left is a cheaper method of placing contact sheets in paper jackets meant to hold 8″ × 10″ negatives and/or prints. The negatives would be filed in glassine holders and slipped in back of the case.

write in (lightly) the file number that indicates the contact sheet and specific frame. Place the print face down on a hard, flat surface before stamping the back lightly with ink. Too heavy a touch will cause the ink to seep through to the other side, making your name visible when looking at the front of the print. This will result in immediate rejection.

The purpose of all this is to ensure that you will be able to find pictures in your files with a minimum amount of searching. Without such a system, you will spend many wasted hours thumbing through contact sheets, then more time trying to find the appropriate negatives.

MODEL RELEASES

File model releases separately. There are two basic release forms, which you can buy in local camera stores. You don't need to go to a lawyer to have one prepared. In fact, most lawyers have so little knowledge of this aspect of the law that your chances of getting misinformation or an

incomprehensible release are great. In addition, models tend to trust general forms more than the specially prepared statements.

The simple release form is printed on a 3″ × 5″ card and is sold by the dozen in a slipcase. Keep them in your gadget bag and use one whenever there is a quick need. It gives you permission to sell the photo and you can mark on it the fee paid.

As a minor point of law, always pay the model at least $1 when the release is signed. Do so even when the model doesn't want any money from the sale of the photo. The $1 payment makes the release a valid contract.

The second form is longer, with plenty of space for you to write in special clauses. Use these when you anticipate long-term benefits for the model from the sale of her pictures. For example, some of the photographs in this book were taken specifically for use as illustrations, and the model was paid a set hourly fee for her time. Others taken during the same session will be sent to various publications and sold on an individual basis, perhaps many times in the future.

You don't always need a model release, however. When a photograph is used for legitimate editorial purposes, the release is unnecessary. It is only when you use it for commerical purposes or distort it in some manner, including the wording of the caption, that you need permission.

There are some pictures for which you must always have a release on file. Nudes, for example, are a troublesome area. Suppose a girl quite willingly poses nude for you and is delighted with the artistic merit of the final work. The pictures are published and she buys several copies of the magazine in which they appear. You have the release but know it was a "waste" of effort. Several years later, your nude model meets Mr. Right in the form of Johnny Straightarrow who thinks it is immoral even for his own body to be naked when he views himself in the mirror, and the model wants him to think she feels the same way. If he then discovers the pictures, she may tell him that it was a horrible indiscretion on her part and that you published the work without her permission or knowledge. He decides to give her another chance, provided she takes the photogra-

pher to court for "ruining" her name. If you still have that release, you are fully protected.

If you want to study the law as regards photography, read *Photography and the Law* by George Chernoff and Hershel Sarbin (Amphoto), which is periodically updated, and *Photography: What's the Law?* by Robert Cavallo and Stuart Kohan (Crown).

Occasionally, you will have a client who requests that a model release accompany the photographs he or she is either buying or looking at on speculation. Don't send the original. Once the release is out of your hands, you have nothing to prove it ever existed. Send a photocopy instead.

MAKE YOUR PHOTOGRAPHY PAY

Selling your work, whether to a publisher or a model, must be profitable. The trouble is that most freelancers start off without knowing their real costs. They usually charge too little money for the services they perform, a situation that can reduce their chances for success should they become full-time professionals.

Every time you start a photography project, including those that are self-assigned, make a list of all your obvious costs. These include the cost of film, processing (including an envelope and postage when sending the work to a custom lab), travel expenses, if on location, floodlights (If they have a six-hour life and you work for 30 minutes, one-twelfth of their life span is gone. Determine one-twelfth the replacement cost, with tax, and this is your cost for that assignment.), props, printing costs, and more. Then figure your hidden expenses, such as electricity, rent for the area where you are working, (including for a home studio), car operating cost when traveling to and from location, and related items which many beginners overlook.

You will have to estimate many of these costs, but this is easier than you think. You can easily learn the current drain of heating and air conditioning units from information attached to them, the owner's manual, or salespeople, and the utility company can supply you with information about your cost of electricity per kilowatt hour. Once you know

how many watts you burned for a set length of time, figure the number of kilowatts burned (1 kilowatt equals 1,000 watts, or two 500-watt flood bulbs) per hour and multiply this by the cost of electricity as provided by the utility.

Add any waste. Some photographers forget that test strips used in the darkroom are just as much a cost factor as the number of finished prints, while others overlook the cost of accidents, as when roll-film camera is misloaded and the entire roll must be discarded due to improper exposure.

Finally, calculate the total time you spent on the project, including packaging everything for the printer, if you send out your lab work. Add a set dollar amount per hour for your time, and you have your basic costs for a photo session.

When you're selling photographs on an individual basis, consider the price of film, processing, printing, and all mailing costs, including envelopes. When you have never sold a photograph before, an offer of $10 or $15 may seem quite reasonable for a single black-and-white. However, when you figure what the photograph cost you in expenses, you could be losing money on the sale.

SALES MARKETS

There are generally four ways to sell your photographs. Newspapers often buy photographs of models when they can be tied into news in some way ("Linda LaBody relaxed in her bikini as the temperature reached 101 degrees for a record-setting fifth day in a row ..."). The editor will offer a fee that is competitive with other newspapers of comparable size, but which is quite low since the picture is not of hard news value. Sell the print on a "one-time rights" basis in this case, because a wire service affiliate might pay you and then place the picture on the wire and send it all over the country. Usually, you get no additional payment for the other papers using it. With one-time rights sales, you can often make more money should the editor decide to put your picture on the wire, with the understanding that each user must pay a fee.

Magazines' pay scales vary with their circulation, the way the print is used, and its importance to the publication. A magazine that reaches only a few thousand readers won't have the budget of a *Playboy*, which is read by millions. Thus, you can expect offers as low as $10 to $15 per black-and-white print to a high of several thousand dollars for a major color feature in a mass-circulation magazine. The pay will be less, if the pictures are fillers, than if they form part of a main story or featured photo section.

Cover photographs generally provide the highest per print income you can get. The fees range from $50 for a color photo used on a limited circulation publication to several thousand dollars on a major magazine.

Book publishers have set rates for photos bought on an individual basis. These are usually quite low and, as with newspapers, you should offer one-time rights only. If a book of your photographs is to be published, you will usually get an advance plus a percentage of the book sales. You receive no royalty checks until the book earns enough money to cover your advance. If the book never earns back your advance, you still get to keep all the money you were paid. This is a publisher's gamble.

The percentage you receive varies with the publisher. The most common arrangement is for 10 percent of the first 5,000 copies sold, 12½ percent of the next 5,000, and 15 percent for all copies in excess of that figure. Some publishers pay a flat 10 percent, while others, primarily paperback houses, pay less. Payment is usually based on the price at which the publisher sells copies to distributors and bookstores. At times, it will be based on the retail selling price, which is considerably higher.

Advertising agencies and public relations firms also buy model photographs, and here the price depends on you. Even though this type of photography may be little more than a hobby and for spending money, price your work to be competitive with area professionals. Remember that if your photography is good enough to be sold to area businesses, it is good enough to earn the same rates being charged to full-time pros.

The price you charge will also depend on the city in which you are competing and the quality of your work. If

140

your work is of professional quality, then the price for your time and your prints should be comparable as well. To learn what this means, talk with area professionals to discover their rates.

If your work is unusually good, or you can offer a unique perspective, you should charge more. To get an idea of what prices are charged nationally and also how to figure prices beyond those mentioned in this chapter, refer to *The Blue Book of Photography Prices* by Thomas Perrett (Photography Research Institute Carson Endowment, 21237 South Moneta Ave., Carson, Calif. 90745) and to *Estimating Manual for Professional Photography* by Professional Photographers West, Inc., (1665½ Veteran Ave., Los Angeles, Calif. 90024). Assistance is also available through The Society of Photographers in Communications (formerly the American Society of Magazine Photographers) 60 East 42nd St., New York, New York 10017, which offers guidelines on prices, day rates, stock sales, general ethics, and more.

SELLING YOUR PHOTOGRAPHS

Pictures of pretty girls must generally be sold on an individual basis unless they form part of a feature story, particularly for men's magazines. A number of publications, primarily romance and confession magazines, like to use pretty girls on their covers. Publications such as *Glamour*, *Seventeen*, and *McCalls* rely on a special cover to "grab" the reader. Sometimes they use a celebrity's photograph or that of a "name" model with special hairdo or clothing, all described inside.

Check out the magazine covers at any large newsstand to find the ones using models who are neither "names" nor specially dressed. Then contact the editors to learn if they are interested in seeing your work on speculation.

Another market is Good Publishing Company, a black-oriented magazine publishing house, which produces magazines ranging from *Sepia* to *Soul Confessions*. Check out the current needs of this and other publishers before mailing any work.

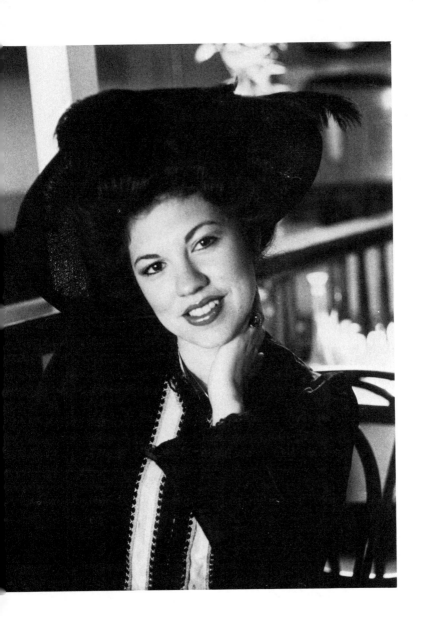

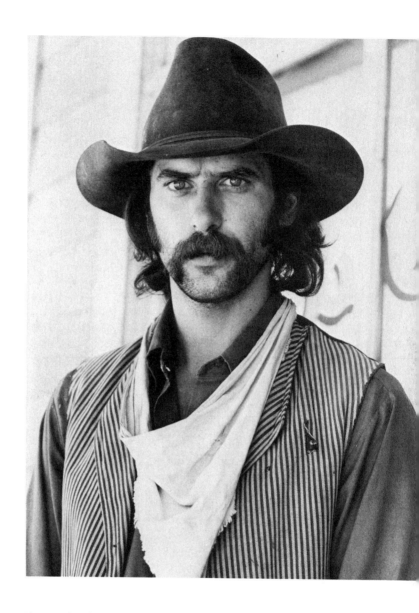

Photos such as these have a variety of marketing possibilities.

SENDING YOUR WORK OUT ON SPECULATION

Before mailing any photographs to a publisher, send a letter explaining that you are a professional photographer with photographs you feel fit the format of the magazine. Ask if you can send samples on speculation and whether they prefer black-and-white prints or color transparencies. If the latter, ask if they accept 35 mm or if they want nothing smaller than 2¼" × 2¼". Don't worry if you only own 35 mm. Knowing what a publication can use will help you in the future. If you don't have medium-format equipment and that is the size they accept, file the response and wait for the day when you can either own, rent, or borrow a larger camera for such work.

Always enclose a self-addressed, stamped envelope for the magazine's reply. This is a sign of professionalism and the only way you will be certain to hear from the magazine.

Once you get a go-ahead to send photographs, you must package them carefully. Send only your best work. An editor would rather look at two or three slides which are perfect for the magazine, than 20 or 30, the bulk of which are of no value. Use plastic slide holders that fit into notebooks and have pockets for twenty 2" × 2" slides or six 2¼" × 2¼" when storing or mailing your work.

The same is true for prints. Use page protectors, placing two 8" × 10" black-and-white or color prints back to back. These add weight to your mailing, but the extra postage is less than the cost of remaking even one print should it be mishandled in the mail due to poor packaging.

Next obtain a photo mailer large enough to hold everything. These are heavy-duty envelopes filled with corrugated cardboard to protect the prints from being bent, tromped upon, or otherwise abused. Place your name and address on the mailer and include enough postage so that the publication can return envelope, cardboard, and prints to you. If "First Class," make sure you print this information in bold letters on the front and back of the envelope. Larger packages are frequently treated as "Third Class" mail unless a package clearly states otherwise.

Place the self-addressed, stamped photo mailer, prints, and/or slides in a larger envelope addressed to the

editor of the publication and send it First Class. Editors are always more receptive to pictures and articles sent this way.

If you don't use plastic protectors for your prints, place them between two sheets of corrugated cardboard and lightly tape the cardboard together with masking tape to prevent the prints from slipping. Mark the cardboard: Save For Print Return, or it may be thrown out and the prints dumped loosely into an unprotected envelope for return to you.

Never send slides in cardboard or plastic boxes even though that is undoubtedly the way the lab sent them to you. The reason is that cardboard boxes are easily crushed, while the plastic ones tend to splinter. Plastic shards may slice through the emulsion.

In addition to the confessions and similar publications, consider sending your pictures to photography magazines, male-oriented magazines, and even trade journals and specialty publications which include one or more photographs of attractive models in every issue.

Dance and theatrical photographs have a larger market. A number of publications listed in Writer's Market and various market guides deal exclusively with these fields. They frequently buy unusual photographs for cover and inside use. If you happen to have celebrity photos among your holdings, the various fan magazines will also be markets. Local newspapers frequently buy photo features on area productions, provided they are different from what their staff photographers may have taken.

OVERSEAS MARKETS

Your pictures will also be in demand abroad, so check *Where and How to Sell Your Photographs* and the Bureau of Freelance Photographers for overseas marketing information. There is a slight difference when sending material overseas. A self-addressed envelope is still essential, but instead of stamping it, include an international reply coupon, sold at the post office. This allows the recipient to obtain proper postage in that country.

There is a very low rate for sending photographs overseas provided no letter is in the package. The package

can be sealed and the customs declaration marked: Photographs of no commercial value. The accompanying letter goes in a separate envelope which you attach to the front of the package. Also address the package itself, in case the letter accidentally comes off. In this way, you pay a high air mail rate only for the letter; the package, also traveling by air, is priced more reasonably under international mail rates.

SELLING TO THE MEDIA

To learn the needs of your local newspapers, contact the managing editor. This is the person responsible for overall editorial, including the purchase of special features. Call and ask for an interview. The best time to call is when the newspaper is not under a deadline. For an afternoon paper, the pressure begins building around 9 a.m. and doesn't let up until around 2 p.m. Call after that time. For a morning paper, late morning is the best time to call.

At the interview, explain the type of photography you are doing and bring along examples of what you are interested in selling. Be certain it is your best work and that you select a medium that fits the paper's format. Color slides are meaningless if the daily paper uses only black-and-white. However, if the paper is large enough to publish its own weekend magazine supplements, the color may be appropriate there.

PUBLICATIONS

Handle book publishers as you would the magazines. Often, you will be switched to an art buyer, but working through the editor is the best way to start. One caution with books and magazines: the editorial turnover within these fields is often quite high, and the editor listed in a market guide may have been replaced two or three times by the time you make your query. So address your correspondence to the editor and not to a specific person.

Publications have a three-month lead time in most cases. This means that the minimum time in which they can publish photographs or articles is three months after they

have been accepted. They usually want more time—as much as six months in advance. If you send Christmas-oriented material to a magazine in November, or wait till June or July to submit summer pictures, your work may be rejected on that basis alone. If your work is seasonal, keep a calendar that is always five to six months ahead to enable you to remember to make appropriate submissions.

AGENCIES

When trying to sell to advertising and public relations firms, make up one or two portfolios of your best, most dramatic work. These should either be made from 8" × 10" or 11" × 14" prints. Anything smaller will not be impressive. Anything larger may be too large to be viewed effectively.

Keep separate portfolios for black-and-white and color images. When combined, the color tends to detract from the black-and-white because of its potentially greater visual impact on the viewer.

Never carry slides to an agency unless they have been specifically requested. Take prints instead. If you carry trays, the office may not have a projector; and if you bring a projector, there may not be adequate space for projection.

Portfolio cases made from quality plastic or leather are available through art supply stores and, occasionally, stationers. These are zippered cases with plastic page protectors that hold two prints to the page (back to back).

Don't carry loose prints or photographs of different sizes. Neither approach is considered professional. However, if you have published work, include tear sheets, also placed in the plastic.

Call the agencies and make appointments with the account executives. Dress formally and take along some business cards. Show your work, discuss your specialty and the possible needs the account executive may have. Some will have no interest in buying model photographs but may like your style well enough to invite you to try your hand at some other area for which the agency has need. Others will say they aren't interested. A few will either buy your work or say that they do have need for such photography from time to time and will call you.

147

Chances are you will not get an assignment the first time you meet with an account executive. If you don't, when you get home send a letter to the person with whom you talked, thanking the executive for the time and repeating your interest in working with the agency in the future. Include your address, telephone number, and another business card.

Wait a week to ten days, then call again, asking if there might be something you can do for the agency. Stress that you recognize that since you are new, the agency might prefer to try you on a minor job, and that this is fine with you. If nothing comes from this, wait another week to ten days and make a second appointment to see the person, preferably with new pictures.

Never leave a portfolio with an account executive: The pictures might get lost or damaged. If the person is pressed for time, offer to come back another day to show your work. However, if the agencies in your area prefer to have a visual record of your work, make a composite. (A composite shows four to eight images on a folded sheet of paper which fits into a standard file folder.)

Be certain your portfolio is appropriate for a particular agency. For example, nudes are seldom needed in advertising; likewise, a firm that handles industrial public relations has no need for a bikini-clad "wench" running across the sand. If some of your photographs show models holding products, this can be a plus with an advertising agency. Use some thought and vary the prints in the portfolio to fit the needs of the particular firm.

Many businesses make unique gifts for their customers at Christmas, including special calendars. This means an additional local market for your work. You may be able to sell the pictures directly to the companies, or you may have to sell the entire calendar based on your samples. You will find sources for calendar companies, if area printers can't handle the job, in the advertisements in professional photography publications such as *The Rangefinder* (1312 Lincoln Blvd., P.O. Box 1703, Santa Monica, Calif. 90406). In addition, large camera stores often sell calendar overlays, as do some processing labs serving professionals.

OTHER MARKETS

One frequently overlooked source of model photography sales is the business that offers artwork for home and business use—stores selling home and office furnishings, an interior decorators, local art galleries, or gift shops. These are businesses which will be interested in photography as fine art.

To reach this potential market, first evaluate your photographs to determine which ones have the greatest appeal when viewed alone. When approaching galleries, interior designers, and similar businesses with your work, have prints made to use as samples.

Once you select the black-and-white and/or color pictures you feel someone might enjoy hanging on a wall for several years, have the best possible prints made. For color from slides, use Cibachrome; this is the most fade-resistant dye currently available. Remember that you can't charge a high price for an image that may disappear after a few months of exposure to light.

For the best black-and-white prints, use archival processing and mounting; you don't want paper acids to destroy an image that should otherwise last a century or longer. Remember that your photography is competing with original paintings for wall space, and the buyer expects a lasting image for the money spent.

Mount your sample prints. Assuming they lend themselves to varying sizes, have some as small as 5″ × 7″ and others as large as 20″ × 24″. Make sure the images are visually effective in the sizes printed.

Don't frame your photographs, at least not until they have been sold to a dealer or decorator who can advise you about framing, because taste in frames varies from person to person. If you feel additional protection is essential, purchase a thin plastic covering, available in roll form from art supply stores, and use this to temporarily wrap the print.

List your costs for having both black-and-white and color prints made and mounted in the various sizes. Dealers take a percentage of your sale price as a commission for handling the pictures, so you want to be sure that the selling price includes dealer commission and total production cost

by a wide enough margin to ensure you a healthy profit. The profit per photograph can be fairly low if you plan to sell a large number of prints from the same original transparency or negative. However, if yours is a unique item or of limited edition, then the profit should be considerably higher.

ART GALLERIES

Among the businesses you can approach with your model photographs are the various art galleries and gift shops in your area which carry original arts and crafts. Take samples of your work to the owner at an hour when the place is not busy. Call ahead for an appointment when possible. Most galleries will not buy work from you but will accept it on consignment. This means that you provide the prints, the gallery provides the display space, and no one makes any money if the customers don't buy your work. Occasionally, the gallery requires you to pay a fee for exhibiting your work. Some will also expect you to supply frames or pay for framing.

Try and work with a gallery that accepts your work on consignment and supplies both framing and space without charge to you. The gallery's "take" will be anywhere from 30 to 60 percent depending upon its expenses and, to a lesser degree, greed. The greater the gallery's promotion, the greater its expenses and the larger its share of the selling price. This is only fair.

A few galleries around the country handle nothing but photography. Some handle only the works of historic and "name" photographers. Still others are receptive to new talent. *Photographer's Market* is a good source for their names and addresses.

Take advantage of the fact that your photographs are hanging in a gallery or business establishment. Photograph the wall(s) where they are displayed and use the pictures when soliciting new business. Be certain the pictures you show are appropriate to the needs of the business whose patronage you seek.

DECORATORS

Interior decorators are listed in the *Yellow Pages*. Some act as advisers to their clients, others supply the

furnishings and are frequently connected with a department or furniture store. Your best approach is to call for an appointment to discuss you work and possible selling arrangements. The decorator will have you set a price for your work, then will add a percentage to that sum when charging the client. Framing will probably be handled by or with the advice of the decorator.

Many department stores offer decorating services. Although they limit themselves to furnishings sold by the store, there is a good chance they will consider using your work if there is no department offering wall hangings which would compete with yours.

RESTAURANT, CLUBS, AND FRANCHISE CHAINS

You can also sell directly to businesses. Restaurants, for example, like to have paintings and photographs on their walls. Keep alert to existing restaurants with space for your work, and watch for restaurants under construction in your community. In many areas, the story of a restaurant breaking ground or about to open is considered newsworthy. If the restaurant owner isn't listed out front, you can get the name from the construction company.

Restaurants will either purchase your prints outright, framed and hung, or put them on their walls at your expense, prices attached and your name and address available to anyone who wants to buy a print. The latter situation represents a substantial cash outlay on your part with no guarantee of returns, so be cautious about committing yourself to such an arrangement.

Nightclubs and discos are potential markets for nudes and related photographs, and the arrangements will be similar to those made with restaurants.

If your photography hangs in the local branch or franchise outlet of a multi-area chain, find out the location of the home office, then contact the company head about the possibility of putting your pictures into more outlets. If each place is operated independently in terms of decorations, ask for the addresses of the different locations. Then contact each manager and enclose a small picture showing your work hanging in the one outlet. Ask if you can send samples

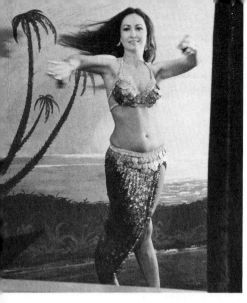

These pictures, of a hairstyling salon and the model/dancer used as entertainment, were sold time and again, both individually and as a feature story, in several countries.

or talk further on the telephone. Include both your telephone number and a self-addressed stamped envelope. Stress that the owner should call you collect. By sending both a return envelope and your telephone number, you should get a response.

If you do get the job to supply photographs to a chain, try to keep your costs down. This means, providing the mounted prints but no frames. Your price per restaurant can be slightly lower with a large sale, but if your standard rate seems reasonable, don't offer to reduce it. Most likely the restaurant will not want you to sell the pictures to any other business, so that series of sales will represent your total profit. Under such circumstances, charge a higher price.

If you make a large sale to a chain, make sure you get a down payment equal to your lab fees. Cover your expenses in advance to keep your out-of-pocket cost to a minimum.

Some chain establishments, located in several cities, prefer to maintain a certain consistency in their office decoration. If you live near a corporate headquarters, you may be able to sell your work for use in all the branches.

MODELING AGENCIES

Another area for promotion is with the modeling agencies in your community. You could supply photographs for the walls in exchange for the agency personnel giving out your name and telephone number to models seeking portfolios. Although this will cost you the price of prints, anyone whose work hangs in the agencies will likely be considered the "best" photographer in the area by would-be models. They will assume the agency director would not allow your work to hang unless you were especially skilled. Though this may be true, and certainly the agency will not hang poor-quality prints, a more compelling reason may be that you are the only photographer to provide such prints.

Other possibilities include record-album covers, greeting cards, and postcards. The pictures are highly salable and it won't be difficult for you to market them.

STOCK PHOTO AGENCIES

One specialized market for your work is the stock picture agency, the majority of which are found in the major cities. Stock agencies maintain libraries of slides and prints covering every conceivable subject. Some are specialists, requiring only pictures of pretty girls, animals, underwater photography, or historical images. Still others want pictures of every subject including the most obscure. Their files might consist of a few thousand or as many as several million pictures. Some agencies might want color exclusively or only black-and-white. However, the majority want both.

Most stock agencies charge a minimum use fee of from $35 to $50 to as high as thousands of dollars. They sell to publishers, advertising agencies, and others.

When you send your work to a stock photo agency, it is evaluated in terms of salability for their markets. If your work is accepted, the agency puts it on file and you sign a work agreement giving them the right to handle your pictures for a set fee. This ranges from 40 percent to you and 60 percent to them or vice versa. The buyer gets one-time use of the photo in a certain field. Thus, a picture might sell to a record company and then be retired from any future sales to such a business. However, that same picture can be sold to magazines, advertising agencies, publishers, and the like.

The sheer volume of material the stock agencies maintain will prevent you from making regular sales unless your work is unique or at least highly unusual. Often, it takes several years for a picture to sell, because of the competition. The people who make the most money from stock agencies are those who have a good photographic eye and can place at least a thousand pictures a year with the same agency.

Use the stock agency as a last resort. Create your own stock agency by contacting publishers and advertising agencies as outlined in this book. Only when you have exhausted every possible market should you send your work to a stock agency.

To select a stock agency, study the market guides and contact those which interest you. Find out their needs, the type of work they seek, and the number of pictures you should have on file to make it all worth your trouble. Then check with the Better Business Bureau to see if there have been complaints about the agency. If the company is fairly well established in terms of years in business, this is a good sign.

Finally, once you have decided on a particular agency, continue sending pictures to it. The more they have, the better your sales opportunities. But again, use stock agencies as a last resort. You will probably make far more money in the long run if you first rely upon your own marketing capabilities.

PORTFOLIO FEES

As mentioned earlier, another way to make your photography pay is to charge models to produce their portfolios. Some photographers have a set fee for which they give the model from 10 to 20 different prints. They have one rate for black-and-white and a second for color. They take a set number of photographs in sessions that never exceed a certain number of hours. Sometimes the work is excellent. At other times it has a sameness about it which does the model a disservice.

One of the best ways to handle portfolios is to charge a model an hourly rate plus all expenses, including mailing costs to the processor if you don't do your own. Under this arrangement, you work as long as is necessary to get the special effects the model needs. If she is short on money, schedule the work in a manner she can afford—perhaps an hour one week, two hours several weeks hence, and so on. Your hourly rate should be as high as is realistic in your area—perhaps as much as $35 per hour or as low as $10 to $15 an hour plus expenses.

It is a good idea to advertise that you are taking model portfolios. You can use the classified ads section of your daily paper to promote yourself. The ad should clearly state that you are selling portfolio services which the model can

use when job hunting. Maintaining truth in advertising is extremely important. Also take out ads in area high school and/or college papers and yearbooks—if you can afford the price of the latter.

Make sure that actors, actresses, and models buying your work pay you in advance or, at the latest, on delivery. Such individuals are notorious when it comes to paying. Even when they sincerely want to pay a bill as quickly as possible, the nature of their work is so unstable that they may not have the money.

Model photography need not be a profession that merely pays for itself. With a little sales effort on your part, you can have fun and make money photographing beautiful women and handsome men.

Appendix

Metric Conversion Information

When You Know	Multiply by	To Find
inches (in.)	25.4	millimetres (mm)
feet (ft.)	0.3048	metres (m)
miles (mi.)	1.609	kilometres (km)
ounces (oz.)	28.349	grams (g)
pounds (lbs.)	0.453	kilograms (kg)
pounds per square inch (psi.)	0.0703	kilograms per square centimetre (kg/sqcm)
cubic feet (cu. ft.)	0.0283	cubic meters
Fahrenheit temperature (F)	1.8 after subtracting 32	Celsius temperature (C)

ASA AND DIN FILM SPEEDS

ASA	DIN	ASA	DIN	ASA	DIN	ASA	DIN
6	9	25	15	100	21	400	27
8	10	32	16	125	22	500	28
10	11	40	17	160	23	640	29
12	12	50	18	200	24	800	30
16	13	64	19	250	25	1000	31
20	14	80	20	320	26	1250	32

INDEX

Actors and actresses, 10
Advertising photography, 12
Agencies
 advertising, 140
 modeling, 17, 53, 115-116
Annual reports, 14
Appearance, professional, 53

Backgrounds, 110
 seamless, 58
Barter portfolio system, 96-97
Black-and-white negatives,
 storing, 135-136
Blemishes, 119
Blue Book of Photography
 Prices, The, 141
Book publishers, 140
Brochures, 14
Business cards, 46, 53

Calendar companies, 113
Cameras, 102
Cavallo, Robert, 138
Chernoff, George, 138
Cibachrome, 149
Clients
 potential, 47
 potential theatrical, 63
 visits to, 48-50
Clothing protection, 24-26
Color temperature, 108
Composite, model's, 75
Contact prints, 94
Cover photographs, 140

Darkroom, 59-60
Duct Tape. *See* Gaffer's Tape.

Ektachrome, 132
Entertainers, 69-70
Equipment, 37-39, 101-120
 large-format, 105-106
 lighting, 107-110
 limitations of, 104-105
 minimum, 59
 support, 106-107
Estimating Manual for
 Professional Photo-
 graphy, 141
Extension cords, 130
Eye contact, 119

Fashion model, 20-24
Fashion photography, 10, 19-50
 cameras for, 16-17
 lighting for, 26-27

Fashion shows, 10, 34-37
Film, 37-38
 processing, 68-69
Filter, cross-star, 118
Fire extinguisher, 130
Flash, 109
 electronic, 124
Framing, 149
Freelance Photographers,
 Bureau of, 145
Fuses, 130

Gaffer's Tape, 109
Garment to be photographed,
 nature of, 19
Glamour, 141
Good Publishing Company, 141

Hand positions, 34

Image, business, 51
Internegatives, 134-135

Kodachrome, 132
Kohan, Stuart, 138

Law, photography and, 73-74
Lead time, 146
Lenses, 102-104
 fisheye, 118
 wide-angle, 118
Light(s)
 bounce, 110
 clamp, 108-109
 modeling, 124
 quartz, 107-108
Light meter, 119
Light and shadow, 119
Lighting, 58-59, 121-130
 butterfly, 125, 129
 comfort, 130
 45-degree, 125
 90-degree, 129
 pancake, 129
 Rembrandt, 125
 rim, 129
 standard, 122
 types of, 125-129
Lighting equipment, 17
Lighting the model, 122-124

McCalls, 141
Magazine field, 16
Magazine Photographers, American
 Society of. *See* Photograph-
 ers in Communications,
 Society of

158